OAN COLLECTION

DATE DUE FOR RETURN

BE ... THE

L ...

FINES PAYABLE FOR LATE RETURN:
50p FOR THE FIRST HOUR OR PART OF AN HOUR
10p FOR EACH SUBSEQUENT HOUR
OR PART OF AN HOUR

last revision July 1991 20113

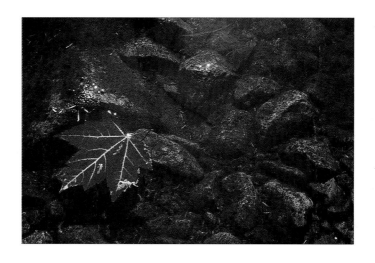

Photographing the
Natural World

Heather Angel

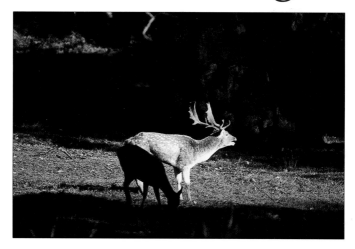

Photographing
THE
Natural World

COLLINS & BROWN

HALF TITLE
Red maple *(Acer rubrum)* leaf in stream

FRONTISPIECE
Fallow deer *(Dama dama)* buck and hind

First published in Great Britain in 1994 by
Collins & Brown Limited
Letts of London House, Great Eastern Wharf,
Parkgate Road, London SW11 4NQ

1 3 5 7 9 8 6 4 2 1000449858

British Library Cataloguing-in-Publication Data:
A catalogue record for this book is available from the British Library.
ISBN 1 85585 185 7 (hardback edition)
ISBN 1 85585 206 3 (paperback edition)

Conceived and edited by Collins & Brown Limited
Editor: Sarah Hoggett
Art Director: Roger Bristow

Reproduction by Daylight, Singapore
Printed and bound in Hong Kong

Designed by John Meek, Toucan Books Limited

CONTENTS

Introduction

Seeing the picture

THE NATURAL WORLD IS FULL OF CONTRASTS. A landscape dominated by hard rock-formations appears timeless; yet the October 1987 storm which crossed south-east England and the raging natural fires that swept through Yellowstone National Park in 1988 dramatically changed within minutes the local landscape for decades to come. Falling snow brings an eerie silence as animals take cover and all sounds are muffled, whereas the cacophony of a nesting seabird colony can be quite deafening. Smells, once experienced, can be unforgettable and evocative, but whereas the scent emitted by frangipani flowers is exquisite, the acute halitosis emanating from a sea lion or walrus colony is quite nauseating. Desert life is adapted to survive for months, even years, without rain; while ocean life cannot live without water. In stark contrast to flowers that unfurl their petals only in response to direct sunlight, inhabitants of deep oceans live and breed in a world where natural daylight never penetrates.

These, together with many more contradictions, make planet earth so infinitely varied – not to mention challenging – for the nature photographer. For me, time, place or subject size are immaterial; I revel in nature's diversity. Despite the fact that I had no ambition to be a wildlife or nature photographer, I have had a great love of the natural world ever since my childhood. It was, therefore, a natural progression to read a zoology degree and later to work as a marine biologist. During this time I

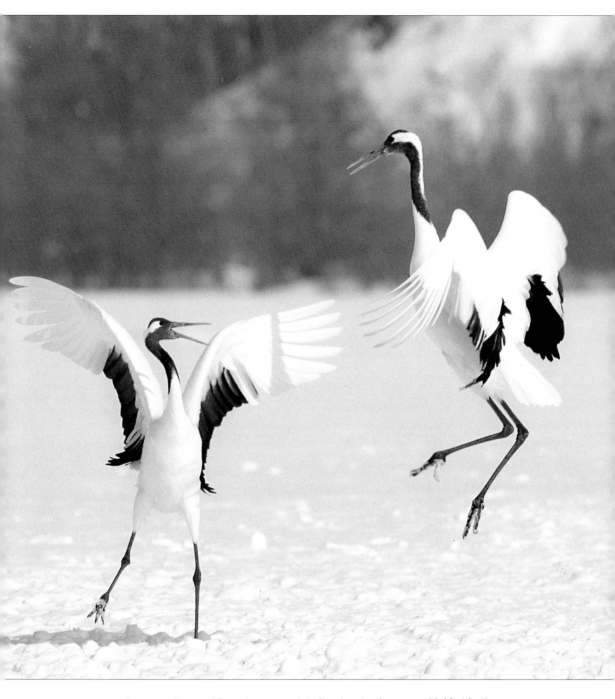

Japanese cranes (Grus japonensis) *dancing in the snow; Hokkaido, Japan*

began to photograph marine life with a camera in order to illustrate my
lectures and thereby inform people about an unfamiliar world. Gradually,
the emphasis began to shift. Instead of taking straight record pictures,
I began to appraise the composition and the lighting. Now, as natural
habitats continue to shrink and the diversity of life on earth is reduced,

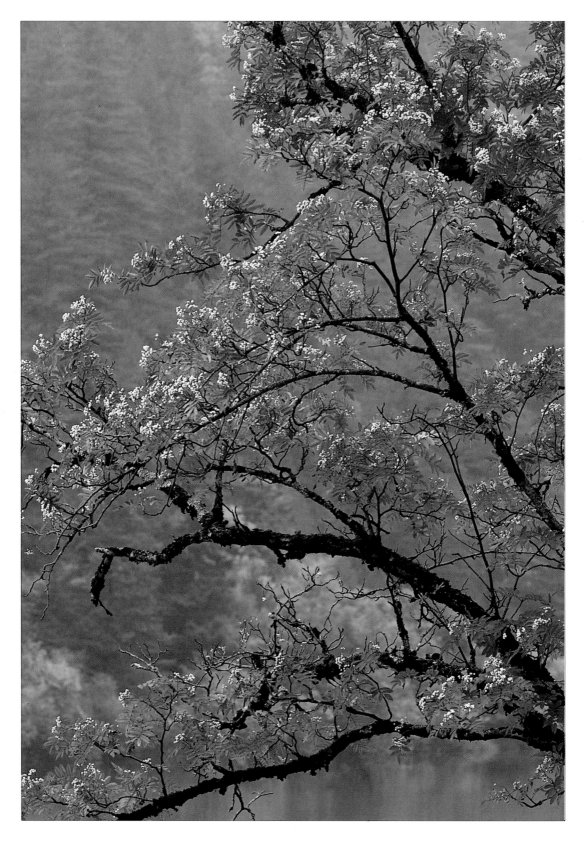

Autumnal leaves and fruits of Sorbus hupehensis; *Sichuan, China*

my aim is quite simply to record magical moments for others to enjoy. Photography is an increasingly important tool for making people aware of facts about the living world which they might not otherwise be able to see for themselves.

Wherever possible, I resist going for the obvious framing; instead I may opt for a narrow-angle view with a long lens to dissect an exciting image – maybe an abstract – from an otherwise conventional broad vista. Simple, uncluttered images are often the most memorable ones, but to be successful they may require considerable thought about which compo-nent – movement, colour or texture – needs to be highlighted.

The way we see pictures fascinates me. There are many ways in which a single subject can be incorporated into a composition, depending on different framing and cropping. Even one of the most simplistic images I know – the fireball of a rising or a setting sun – offers endless scope for variable compositions. It can be positioned low, centrally or high in a vertical frame, as well as centrally or to one side of a horizontal frame. All these options produce images that can be used for different purposes: verticals as posters or cards, horizontals as wrap-around covers or a double-page spread in a magazine. Each crop is a deliberate decision, no one is better or worse than any of the others.

If the lighting is good and the subject powerful enough, I never hesitate to take plenty of frames, because film is relatively inexpensive. Indeed, duplication in the camera is an insurance against losing a picture because of a processing fault. Also, I find that the more time I spend looking through the viewfinder of a camera on a tripod, the more likely I am to improve on the composition by making quite minor adjustments. Static subjects give me the luxury of time to fine-tune my shots, maybe even to open my eyes to possibilities I had not immediately recognized.

After my cameras, lenses and tripod, the most important item I carry on location is my field notebook. In this I record observations about the terrain, the occurrence of animals, their approachability and their behaviour. All this is invaluable for ensuring a higher success rate the next time I visit that location. Natural events are often short-lived, and so wildlife photography – arguably more than any other – requires a great deal of planning. Initially, the geographical location of the chosen species

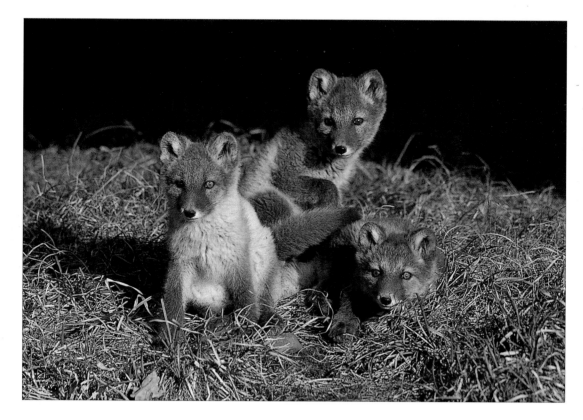

Arctic fox cubs (Alopex lagopus); *Prudhoe Bay, Alaska, USA*

needs to be researched together with its habitat, the times of day when it
is active or likely to be feeding and the times of year when it exhibits
courting or breeding behaviour. The harp seal pup on page 125 and the
cranes on pages 7 and 68–9 are examples of pictures achieved as a result
of much planning and preparation. Even then, problems may still arise.
I can be philosophical about photo opportunities lost due to abnormal
weather conditions or when predators disturb their prey, but not when
thoughtless people frighten my quarry by slamming a car door or rushing
forward with too short a lens. Nevertheless, how boring it would be if
every nature picture was easy to achieve: the challenge would be lost.
After all, the sense of anticipation, with adrenalin pumping through the
body, is the most exciting aspect of working on location.

Despite my careful research, I do not adopt a blinkered approach to
photography. I readily adapt to working with any photogenic subject –
especially if an exciting or unexpected photo opportunity arises or the
primary objective fails to appear. Among my fortunate chance

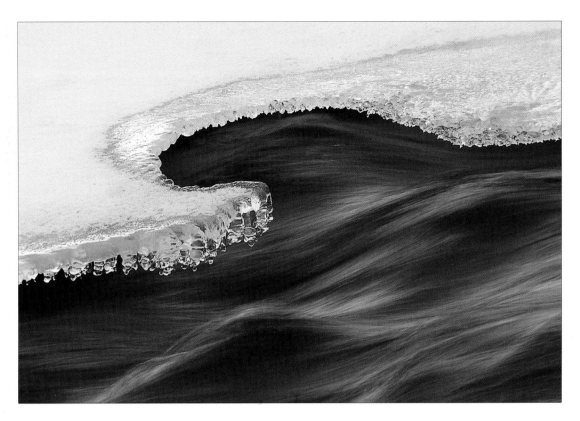

Ice platform with icicles beside creek; Yellowstone National Park, USA

encounters are the storks feeding on insects escaping from an African grassland fire (page 17) and the alpine meadow in Canada (page 75).

Unlike some photographers, I do not measure my success rate by the number of rolls exposed in a day, nor by the number of species taken during a trip. Whether I shoot several dozen rolls or a few frames in a day is immaterial. I can count on one hand the frames taken during a whole trip which are so memorable that they will live with me for ever. Within this category come the Iceland waterfall on page 26 and the ice platform (above). It is coincidental that they are both water shots, since they are separated by 15 years and by more than 3,500 miles. Both pictures illustrate contrasts – one the action of water on a permanent rock, the other of water flowing beside ephemeral ice.

It is a common misconception that every professional photographer is at work behind a camera every day, in the same way as a secretary taps a word processor. In my case, I photograph on only some 200 days of the year but, when I am on location, I work such long hours (up to 18 hours

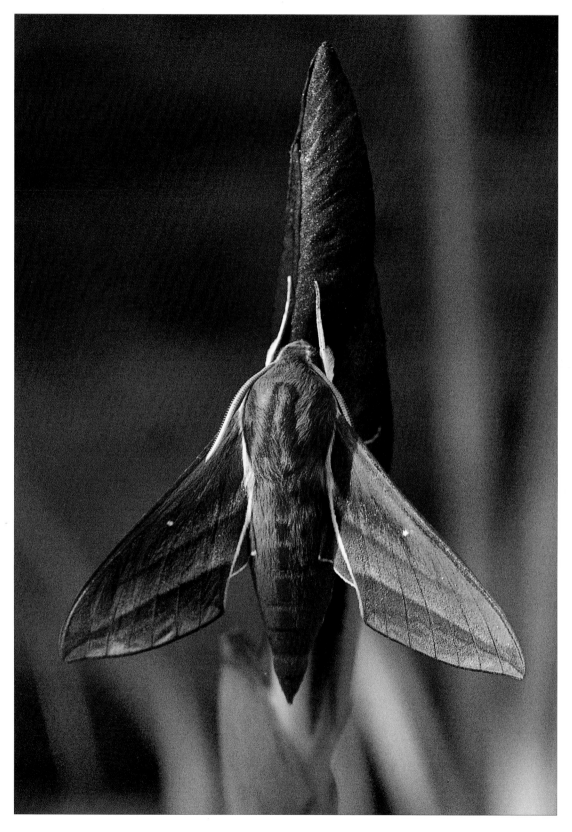

Elephant hawk moth (Deilephila elpenor) *resting on iris bud; Surrey, England*

out of 24 in the high Arctic) that it would be difficult to maintain such a momentum for lengthy periods. Batteries – both human and photographic – need to be recharged between trips. To maximize on any trip, time has to be spent not only on planning and preparation, but also on editing and captioning pictures. Taking them is the fun part; captioning can never be regarded as creative, although this process enables me to relive a trip through the camera's eyes. Also, uncaptioned pictures lying in boxes will not sell.

Sometimes, when I have spent several consecutive days office-bound captioning and writing, I wonder if I should, perhaps, make time to photograph something each day. However, as with any creative occupation, the regimentation of working regular hours is unlikely to produce the best results. This is one of the prime reasons why I have never sought, and have frequently turned down, commissions. Working with animals and to a deadline is courting disaster, and photography succeeds for me when a fleeting moment is seen and captured.

Many of the spectacular close-up wildlife studies seen in movies are achieved by using animals that have been conditioned to work with humans. In the captions to all my wolf pictures (pages 37, 113 and 132-133), the letter (C) denotes that the animals were captive-bred although by no means tame. While some professional wildlife photographers deliberately evade any reference to this fact, I prefer to be honest and admit that I did not stalk a wild animal. Many nature photographers appreciate just how time-consuming it would be to take such pictures of truly wild wolves. A purist will consider that only high quality, sharp images of naturally elusive wild animals are truthful, but at what cost? There is no doubt that the use of wildlife models in published photographs, as well as in movies, arouses the interest and awareness of the public at large, thereby enhancing the likelihood that measures to conserve wolves in the wild gains sympathetic support. In addition, it ensures that wild animals are not disturbed by over-zealous photographers. However, I am prepared to work with captive-bred animals only if I know that they have a caring trainer.

Also, all too often, tourists fail to adopt a responsible attitude towards wildlife. Manuel Antonio is a delightful national park on the

Pacific Coast of Costa Rica where, for the paltry sum of 100 colonas per person (less than 1 US dollar), sun worshippers head for the sandy beaches. Few appreciate the wildlife and, if what I experienced on two consecutive mornings is typical, most will be responsible for its demise. Despite conspicuous notices (in English and Spanish) requesting that the monkeys should not be fed, several people were finding it amusing to feed bananas to white-faced capuchins. Once the monkeys learn to associate food with humans, anyone who approaches the monkeys and fails to produce some may be molested and even bitten. Demands will then be made to make the beach 'safe' by removing or shooting the monkeys. Photographers (and writers) have a role to play in educating mankind about the knock-on effects of thoughtless gestures.

I am extremely fortunate to have spent the last 20 years as a professional wildlife photographer migrating around the world taking pictures of whatever happened to catch my eye. I make no apologies about including a few of my favourite images in this book because they are all relevant to the way I approach my photography and I can still make fresh, valid points about them. The majority of pictures, however, were made within the last few years. The production of this book has enabled me to relive my past, to look ahead to the future and to examine my 'philosophy' of working with wildlife in the 90s. Above all, photography needs to be fun. If it is a chore then you may as well forget it.

Whenever I look at other people's pictures, I always feel cheated if there is no clue about the location and the month the picture was taken; so, unless the plant or animal is endangered, I am always happy to provide this information together with the camera, lens and film I used on each occasion. Because I believe good camera lenses perform better if they are naked (and clean), I rarely use a filter and I would never stack up more than one. I have never seen the relevance of quoting the precise exposure for any of my pictures. For one thing, I do not record the aperture and shutter speed and, for another, the odds of anyone else being in the same place taking the same subject with identical lighting conditions, filmstock, length and speed of lens must be very remote. Take, for example, the polar bear sitting on the ice on page 71. Over a period of almost three weeks at Cape Churchill in Manitoba, this was the

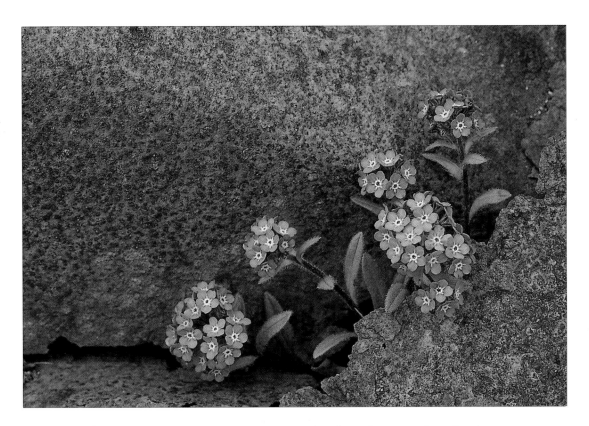

Forget-me-not (Myosotis *sp.*) *growing through a rusty sheet; Russia*

only occasion when I saw a bear sitting on its haunches when the sun was shining. For much of the time the sky was either overcast or it was blowing a blizzard and so the combination of circumstances that produced this picture was quite unique.

Photographs transcend all language barriers; they can be appreciated by anyone irrespective of their native tongue or ability to read. But for any photograph – nature or otherwise – to communicate, it must arrest the attention of the viewer. On whatever subject I focus my camera, I strive to produce a picture that is more than a straight record shot and will receive more than a passing glance. It may be a single facet – the composition, lighting, colour harmony, colour contrast, texture or abstract form – or any combination of these that catches my attention and motivates me to take a camera out of the rucksack. If some aspect of animal behaviour is also recorded, this is an additional bonus. Provided some element in the picture makes the viewer look twice, to read the caption and to develop a better seeing eye, then I have succeeded.

Maximizing Opportunities

Many of nature's best pictures arise from being fully prepared to take advantage of magical ephemeral moments. In these instances the process of seeing, composing and exposing the picture needs to be completely instinctive if the opportunities are not to be wasted.

NATURE PHOTOGRAPHS may arrest attention for many reasons: beautiful or dramatic lighting, intriguing shape or form, particularly striking colour or because they depict some interesting aspect of animal behaviour. All too rarely do these elements come together to form a single memorable image, but the thrill of recognizing these moments is, for me, one of the great joys of photography.

For days I had kept my distance as long dry grassland areas were burnt to stimulate new green shoots which would lure the game back into the Masai Mara – a popular Kenyan reserve. Late one afternoon as my driver was searching for cheetah, we paused on the crest of a hill and saw flames fast approaching one side of our dirt road below. Our instinct was to retrace our tracks, but then I noticed black and white objects moving purposefully in front of the flickering orange line. Binoculars solved the mystery. They were white storks which had migrated south after breeding in Europe.

Initially, I was motivated to record the opportunist storks gorging themselves on wave after wave of insects escaping from a scorching death. Then, as we moved in closer, I saw how I could use the heat haze to advantage to abstract the scene in a way that was reminiscent of an Impressionist painting. Composition was difficult as the fireline and the storks moved constantly. The snaking fireline indicated a horizontal format, but when I saw the pictures I realized that the best shot was a vertical frame made by cropping the original in half.

> **White storks (*Ciconia ciconia*)**
> **feeding on locusts and crickets**
> Masai Mara, Kenya, July
> Nikon F4, 200mm lens, Kodachrome 200

POINTS TO WATCH

- *When a shot contains mobile elements it can be difficult to visualize the best composition. It is therefore worth taking several frames, to be sure of getting something usable, in case the opportunity does not arise again.*
- *Vary the composition by taking both vertical and horizontal pictures.*

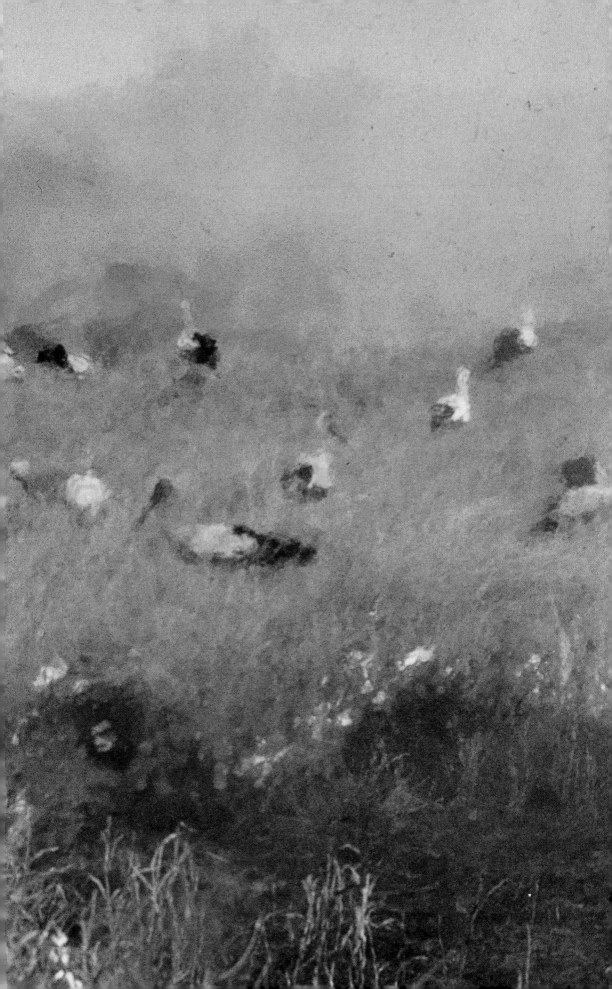

A Seeing Eye

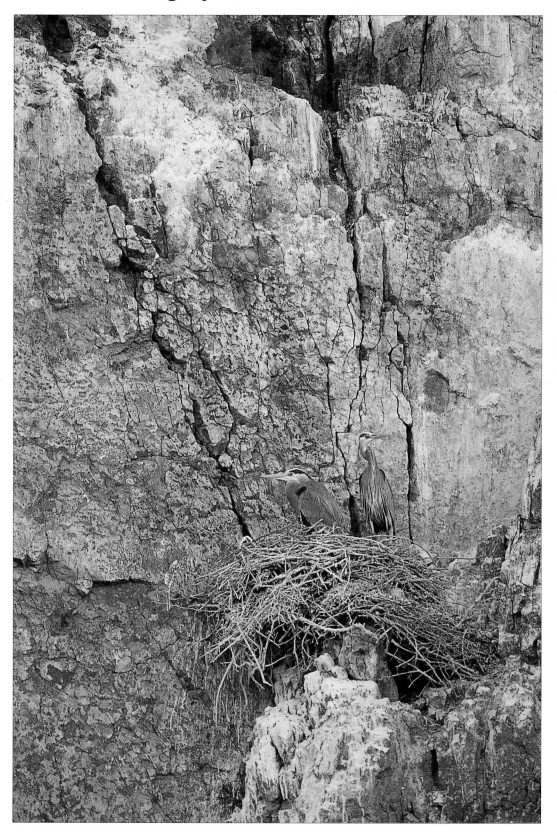

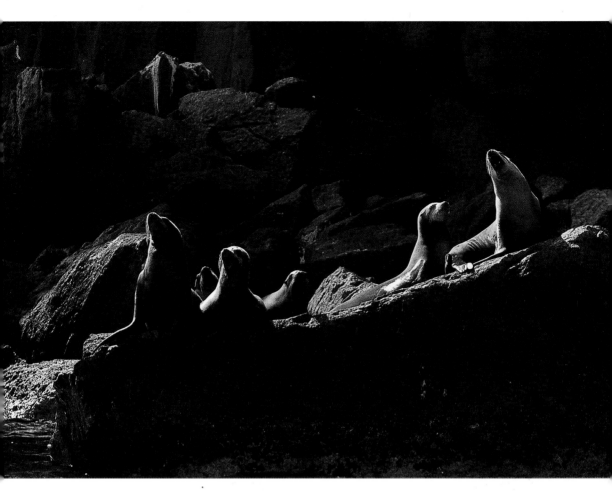

AN ABORTIVE early-morning trip in search of dolphins had a positive ending when we chanced upon this pair of grey herons. Their plumage blends in so perfectly with the rock that I should undoubtedly have missed the birds had the nest not been so conspicuous. Indeed, it was this which made me look twice and realize that here was a picture well worth getting. The grey birds and rock face were both a good average tone, so I had no hesitation in matrix metering the scene, but I found it tiring to hand-hold the camera vertically with a long lens in a rocking boat.

Grey herons (*Ardea cinerea*) on nest
Baja California, Mexico, March
Nikon F4, 300mm lens, Kodachrome 200

● *When entering unknown terrain, in which you cannot pinpoint the whereabouts of wild-life, a useful technique is to begin by scanning the area quite speedily. In this way, you will detect the slightest movement more readily than by focusing intently on a small patch.*

PREPARATION is vital to successful wild-life photography, but even with a specific target in mind, look out for other photo opportunities. Both these unplanned pictures resulted from being in the right place at the right time. By coincidence, both were seen from a small boat in Mexico's Sea of Cortez – albeit on separate trips. I had already taken sea lions front-lit by sun on one side of the island when we rounded the corner to find golden fluid lines glowing dramatically against the dark rocks behind. As I had just manually metered the sea lions in sunlight, I did not have to calculate the exposure compensation with an auto-matic mode for this tricky exposure.

Californian sea lions (*Zalophus californianus*)
Los Isoletes, Baja California, Mexico, March
Nikon F4, 80–200mm lens, Kodachrome 200

● *Make sure the camera is always loaded with film or, better still, use two bodies so that if one runs out of film at a crucial moment you don't have to waste time changing films.*

Harmonious Composition

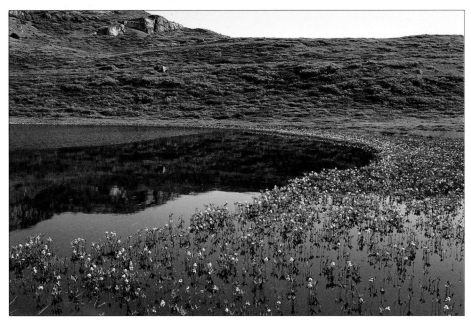

WHATEVER the subject – location, animal, plant or close-up – composing a picture should be instinctive. Time spent deliberating which lens and which format (vertical or horizontal) to use can mean lost pictures.

Look at successful photos (and paintings) with a critical eye. Try to analyse why they work and, without copying them exactly, put into practice some of the compositional principles they exhibit. When I saw this curvaceous band of plants emerging from the ripple-free water on a Greenland lake, I did not hesitate to reach for a medium wide-angle lens, so that I could include the complete sweep of plants, the reflection of the hill and the blue sky in the calm water.

A DIAGONAL LINE (bottom right) can contribute a powerful element to the composition of a picture. Examples found in the natural world include a tree-line along the brow of a hill, a rock ledge and the diverging lines produced in the wake of a bird swimming on calm water.

This dolphin picture was a single opportunist shot which could never have been planned. When I am hand-holding a camera and working in a moving boat, I can never be sure of the precise composition at the moment I release the shutter. In this case I was delighted to find that all five silhouetted dolphins were in line and in focus, while the intriguing abstract pattern on the sea surface was a bonus.

Bogbean (Menyanthes trifoliata)
Greenland, July
Nikon F4, 35mm lens, Kodachrome 25

Common dolphins (Delphinus delphis)
Sea of Cortez, Baja California, Mexico, March
Nikon F4, 300mm lens, Kodachrome 200

POINTS TO WATCH

● *Look for other curves in the natural world such as a snaking river, slopes of hills, a cove, waves breaking on a beach or natural arches to introduce flowing lines to your picture.*
● *Using a camera on a tripod aids precise composition of a picture because slight adjustments can be made to the framing.*

POINTS TO WATCH

● *Spend time searching for static diagonals and ways of incorporating them into the frame. This will train your eye to recognize strong compositional elements even in moving subjects.*
● *The impact of a diagonal line is lost if just a single conspicuous object lies in the space to either side of the diagonal.*

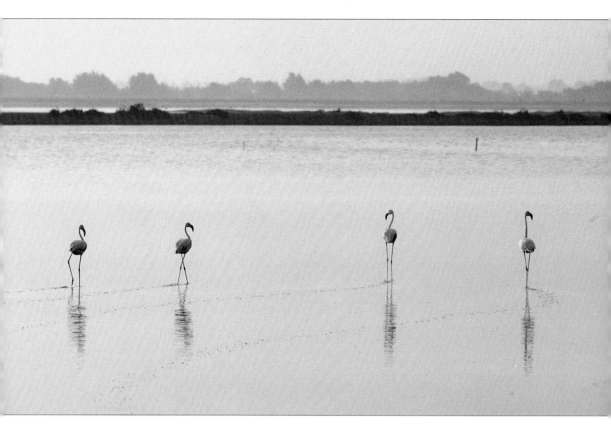

WHILE THE BACKSIDE of a large mammal such as an elephant or a hippopotamus can be humorous, this is not normally the best viewpoint for taking birds. However, what caught my eye with the four flamingos wading though a shallow lagoon at dawn was the trails left by their feet dragging behind them. These strengthen the composition of this simple pastel-coloured picture at first light.

Flamingos *(Phoenicopterus ruber)*
The Camargue, France, August
Nikon F3, 300mm lens, Kodachrome 64

POINT TO WATCH

● *Avoid cutting the image into two equal halves by placing the horizon in the centre of the frame because this creates a feeling of imbalance.*

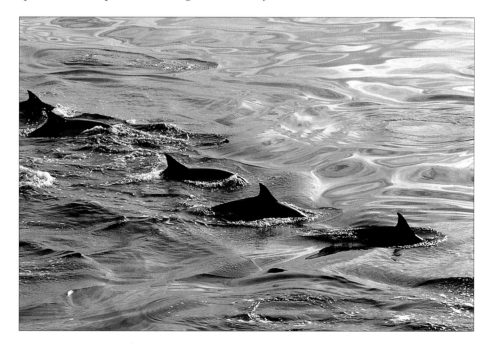

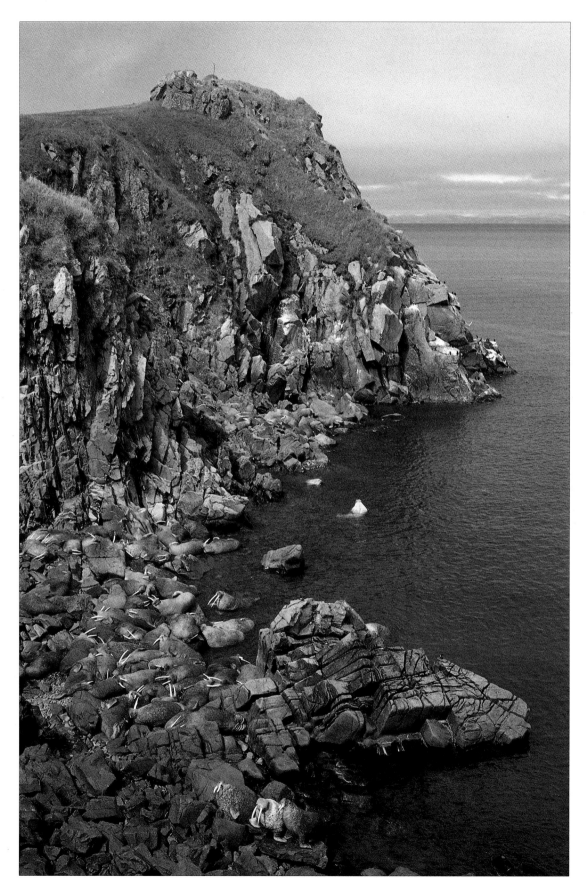

Variations on a Theme

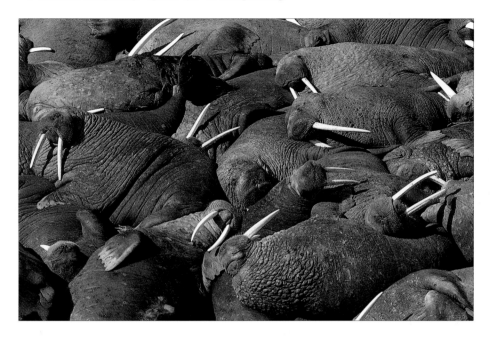

MAKE THE MOST of each location by altering the camera viewpoint and changing the focal length of the lens, so that you come away with many different shots. Never be content with taking just one frame. Places where many animals congregate, yet constantly come and go, are ideal for varying the composition.

Round Island is a walrus sanctuary in a remote part of Alaska. Access to the walrus beaches is prohibited, so all photography has to be done from the cliff-top paths. When I saw the walruses hauled out, I wanted to set the scene with a wide-angle shot; but the cloud was low, so I could take only small groups and individual portraits. My 200–400mm zoom was the ideal lens for a tight crop on the mosaic of blubbery bodies lying on the rocks (above).

I also wanted to illustrate an aspect of the animal's physiology. To prevent heat loss when submerging into the cold sea, the surface blood capillaries constrict, so that the body appears pallid (below). As blood begins to flow back through the surface blood vessels the pink colour slowly reappears.

Late in the afternoon the clouds rolled away, blue sky appeared and I was finally able to get my picture, showing the walruses in their environment (opposite).

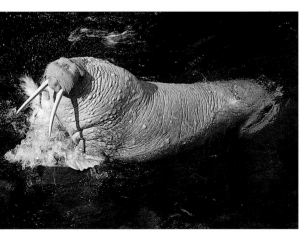

Pacific walruses
(Odebenus rosmarus divergens)
Round Island, Alaska, USA, July
Nikon F4, Ektachrome 100 Plus
Far left: 35mm. Above and left: 200–400mm

POINTS TO WATCH

● *A location such as this is ideal for producing a photo essay. Spend time appraising the situation for ways of getting different viewpoints and magnifications.*
● *A telephoto zoom will enable you to frame both vertical and horizontal shots precisely.*

Pictures with a Purpose

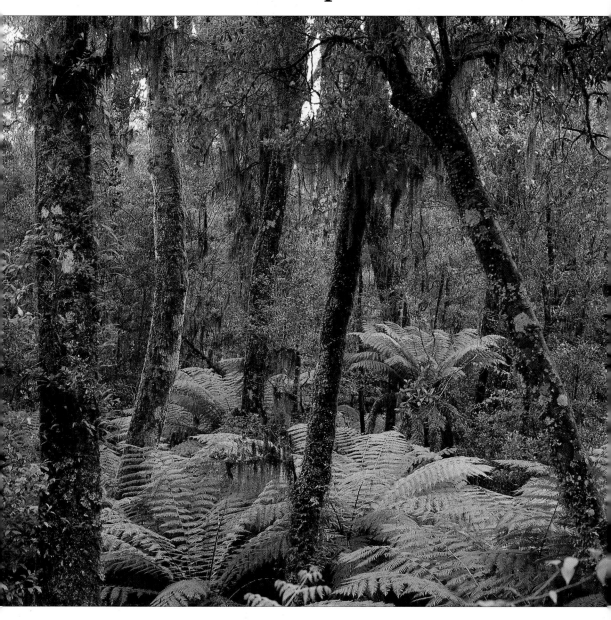

Even though I always choose the location and subject myself because I rarely accept specific commissions, I do need to be alert to topical issues and have a sound knowledge of market outlets for my pictures. Graphic examples of ecological disasters – such as the effects of acid rain or of oil pollution – are always in demand. Pictures with pleasanter connotations include the one above, originally taken to illustrate a temperate rainforest interior. Recently, it has been used repeatedly by companies eager to create a green image.

> **Temperate rainforest with evergreen beeches (*Nothofagus moorei*) and tree ferns (*Dicksonia antarctica*)**
> New England National Park, Australia, January
> Hasselblad 500C/M, 80mm lens, Ektachrome 64

POINT TO WATCH

● *Before you shoot, think about the way your pictures may be used, instead of always looking for a conventional shot. If you are trying to sell your pictures, first research your markets and the way they use pictures.*

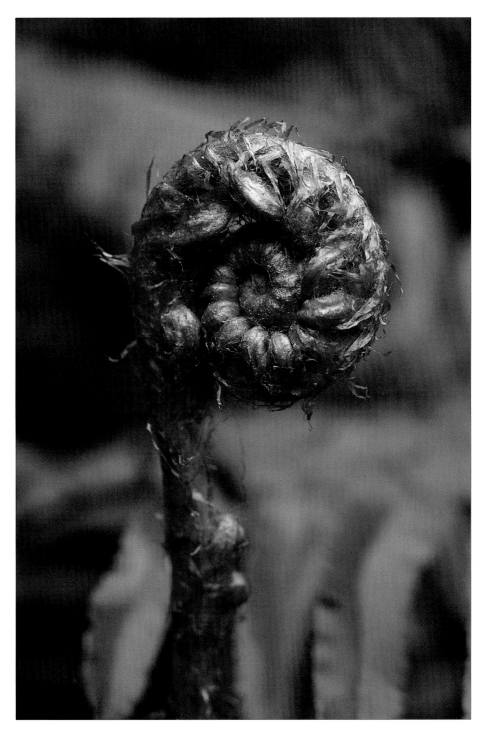

Pᴀᴛᴛᴇʀɴꜱ ᴀɴᴅ ᴅᴇꜱɪɢɴꜱ abound within the natural world (see page 152). From experience, I knew that pictures of natural designs – especially spirals – are often in demand to enliven mathematics textbooks. I knew that this young fern would be a useful addition to my collection of spiral pictures, which include shelled molluscs, scales on cones and climbing vines.

Tightly coiled spiral of young fern crozier
South Africa, September
Nikon F3, 55mm macro lens, Kodachrome 64

POINT TO WATCH

● *Keep a month-by-month notebook to remind you when ephemeral subjects, such as this fern crozier, are likely to appear.*

25

Choice of Film

SELECTING the most appropriate film for the subject and weather conditions is just as important as the choice of lens. I always keep two bodies loaded with different film speeds – slow and medium. Wildlife subjects can be taken using medium speed (100 or 200 ISO), but there are occasions when a very slow or very fast film is necessary. Without a roll of Ektachrome P 800/1600 (rated at 1600 ISO), I could not have taken these wildfowl on a flooded field at sunset. Even so, I had to use a shutter speed of 1/30 second, so there is some movement. I love the painterly qualities of this picture: the orange dusk sky and the birds spotlit by floodlights for night viewing.

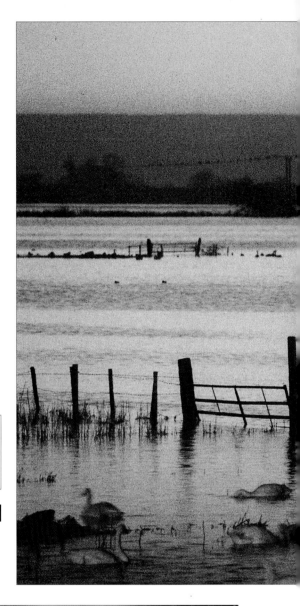

Wildfowl on flooded field from a hide
Ouse Washes, Norfolk, UK, December
Nikon F4, 200–400mm lens, Ektachrome P
800/1600

POINT TO WATCH

● *Keep a roll of fast transparency film to hand for taking distant moving subjects at first and last light when there is not enough available light to use fill-flash with a medium-speed film.*

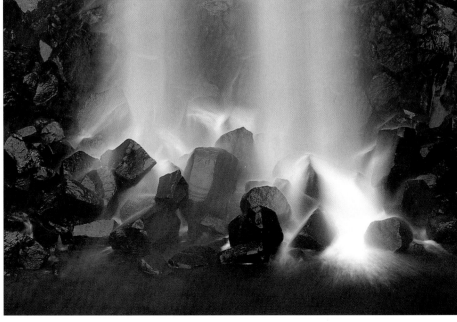

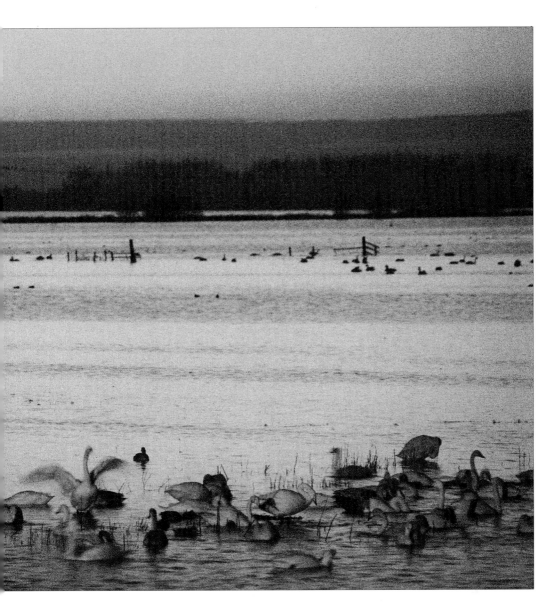

MY PREFERRED FILMS for taking close-ups of plants in calm weather are slow-speed transparency films – Kodachrome 25 and Fuji Velvia (50 ISO), in which the grain is non-apparent. They produce good colours even in dull light. Slow films are also essential for using slow shutter speeds (1/2 second or more) to blur moving water. For me, recording moving water as soft flowing lines is infinitely preferable to freezing it with a fast shutter speed. Indeed, a thin sheet cascading from a waterfall then appears as a translucent curtain, as shown in the photograph opposite.

This picture, taken more than a decade ago in Iceland, is one of my favourite water pictures. It has been reproduced many times – including the back cover of one of my books when, to my horror, a designer cropped the image in half!

It was late in the day when I reached the waterfall, but with Kodachrome 25, I was able to use a one-second exposure to get the effect of the water splashing on to the basalt rocks below. It is the combination of a mobile white subject falling on to static black objects which makes this graphic picture.

Base of Svartifoss Waterfall
Iceland, July
Nikkormat FTN, 200mm lens, Kodachrome 25

POINTS TO WATCH

● *Use a slow shutter speed to blur water only when the water volume is small, otherwise it will appear as a solid white area.*

● *When using any film, you can reduce the effective speed, and thereby gain a slower shutter speed, with a neutral density filter.*

Choice of Lens

SEVERAL FACTORS influence my choice of lens: the subject size, its accessibility and, not least, how I see the composition. I believe it is a mistake to ear-mark a particular lens for a particular subject. I use anything from a 20mm up to a 500mm lens for taking both plants and animals. The lenses used to take these two photographs are perhaps not the ones normally associated with such subjects – but if you play safe and follow a conventional approach, you could miss some great shots!

When stalking large, wild animals, I have to consider how close I can safely approach so that I don't disturb them or risk endangering myself. Animals living in the Galapagos, such as this flightless cormorant, are so approachable that they can be photographed with short telephoto lenses.

Flightless cormorant *(Nannopterum harrisi)*
La Fernandina, Galapagos Archipelago, March
Nikkormat FTN, 135mm lens,
Kodachrome-X (ISO 64)

POINTS TO WATCH

● *Biggest is not always best. It does not matter which lens you use for which subject provided you achieve the picture which most appeals.*
● *Zoom lenses, although not as fast as prime lenses, are useful for speedy, precise framing.*

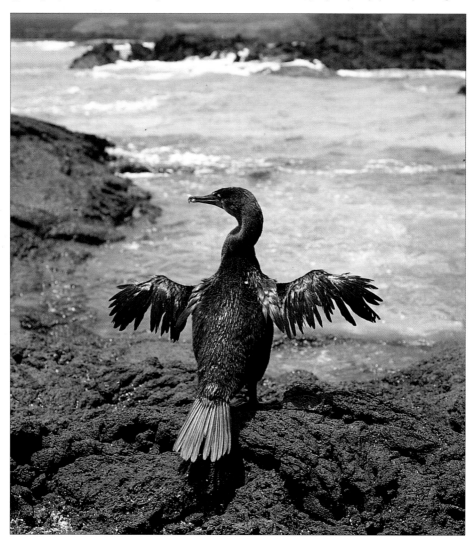

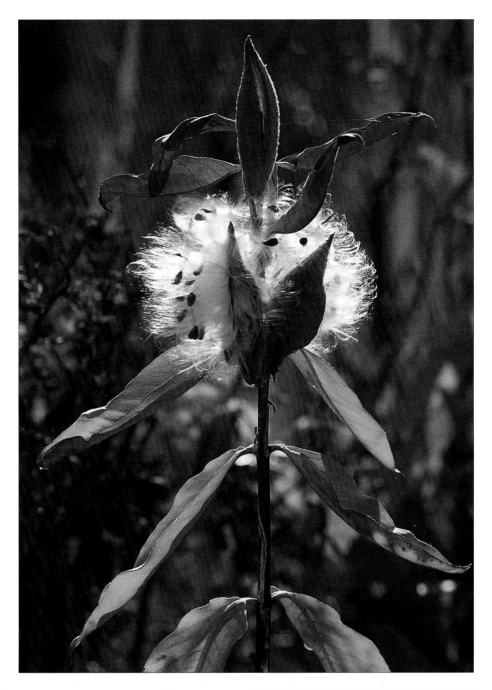

LONG TELEPHOTO LENSES would not normally be top of my list for getting plant pictures but, because I carry them for taking animals, there are occasions when I have managed to get a picture which would otherwise have been impossible. Aquatic plants growing out in the middle of deep water or plants growing on a precarious cliff face need not be rejected if I have my 200–400mm zoom lens with me. Indeed, this is what I chose to use for the milkweed seeding above.

Milkweed (*Asclepias* sp.) seeding
Wyoming, USA, October
Nikon F4, 200–400mm lens, Fuji Velvia (ISO 50)

POINT TO WATCH

● *Whatever the subject, a long telephoto lens will need some support. If you do not have a tripod or monopod, improvize by bracing your body against a tree, wall or vehicle or, if sitting or crouching, by bracing your elbows on your knees or on the ground.*

Appreciating Light

Perceiving and exploiting the variable quality of natural light in the way most appropriate to the subject is fundamental to the success of any photograph. This chapter explores the way light at different times of day can be used to enhance the natural world. Knowing when and how to modify available light is also crucial.

COLOURFUL SUNRISES and sunsets provide scope for dramatic pictures. Many nature subjects, however, can be taken between these extremes of daylight. Indeed, many flowers – notably waterlilies – only unfurl their petals in sunlight, while butterflies require their bodies to warm up before they can take to the wing in search of nectar.

When photographing birds in flight or mammals running, there simply is not time to appraise the available light – other than to check that there is no flare on the lens. But with a static scene you can wait for the light to change or else modify it by using filters. Reflectors, diffusers and fill-flash can all be used to modify available lighting on portraits and close-ups.

Different subjects need different lighting. For instance, dull days are ideal for taking white or pastel-coloured flowers. On the other hand, long shadows can introduce powerful designs – not only to habitat pictures but also to emphasize vertical elements of plants or animals.

During a three-week spell working with polar bears in Canada, only once did I see the reflection of the setting sun on the glare ice, so I was very lucky to chance upon a polar bear walking through the orange beam, allowing me to take several frames. Knowing that the bear would be rim-lit I opted to underexpose the fur so that the reflection of the setting sun on the ice would not be overexposed. I therefore spot-metered from a shadow area on the ice and deliberately included the bear's shadow in the foreground of the frame.

Polar bear (*Ursus maritimus*)
Cape Churchill, Canada, November
Nikon F4, 300mm lens, Kodachrome 200

POINTS TO WATCH

● *If you know the photo opportunity will be brief when the lighting is tricky, work out the exposure before the animal moves into frame.*
● *When taking a static subject, appraise the direction and quality of the light. If it does not enhance the subject, modify it with a filter, wait for the light to improve or return later.*

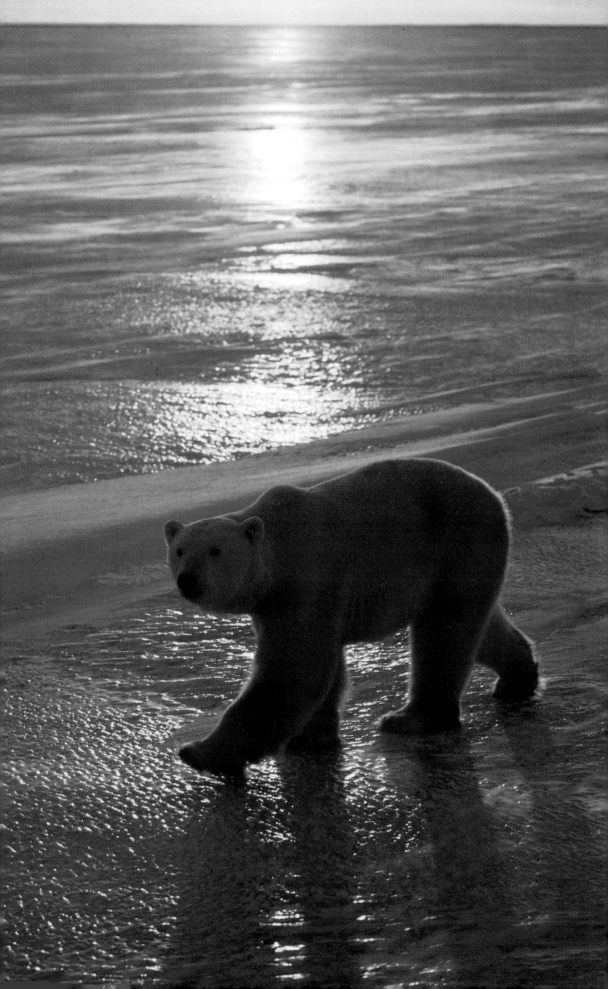

Changing Light

THERE CAN BE no better way of appreciating how the passage of the sun across the sky changes the mood of a picture than by recording the same scene from the same viewpoint at different times of day. In this case, however, the two pictures are separated by a mere half-hour.

Yosemite National Park in California is a mecca for nature photographers, many of whom aspire to emulate the graphic monochromatic images made by the late Ansel Adams. Over the years, so many photographs have been taken of the major landforms – notably the huge granite peaks of Half Dome and El Capitán which tower above the valley floor – that it is difficult to find a novel viewpoint. But at least the framing may be original.

In the morning light, when it is backlit by the rising sun, Half Dome is seen as a silhouette. I wanted to show some detail on the sheer cliff wall which meant an afternoon or evening shot. Before shooting a sunrise or a sunset, I always spend time in advance searching for possible locations. Because my time was limited, I was unable to make any long hikes and so I had to be content with a short walk from Yosemite Valley Road.

When I returned late in the afternoon to take this view of Half Dome, I found several other people had already staked out their tripod patch, so I moved further back and used a longer lens. As the sun dropped, the temperature quickly plummeted. One by one the other photographers packed up and left until I was the only person remaining. My patience was rewarded by the alpen-glow momentarily spotlighting the famous vertical face.

If I think I may want to take a comparative picture from an identical viewpoint at a later date, I note down not only the camera position and lens setting used for the first picture but also line up some permanent landmarks. I used to take a Polaroid print for reference on a return visit, but now that I can so easily get a colour photocopy from a 35mm transparency, I take this into the field instead.

Half Dome, Yosemite National Park
California, USA, January
Nikon F4, 80–200mm lens, Fuji Velvia (ISO 50)
Above: 5.15 pm; Right: 4.45 pm

POINTS TO WATCH

● *At the end of the day, do not be in too much of a hurry to pack up, because the light may improve dramatically after the sun drops below the horizon.*

● *For fixed-point photography spanning weeks or months, do not rely on your memory for the camera position and precise framing of the picture; a scene can change dramatically from one season to another. Make a rough sketch in a field notebook of the alignment of major landmarks as well as noting the camera, lens and distance at which it was focused.*

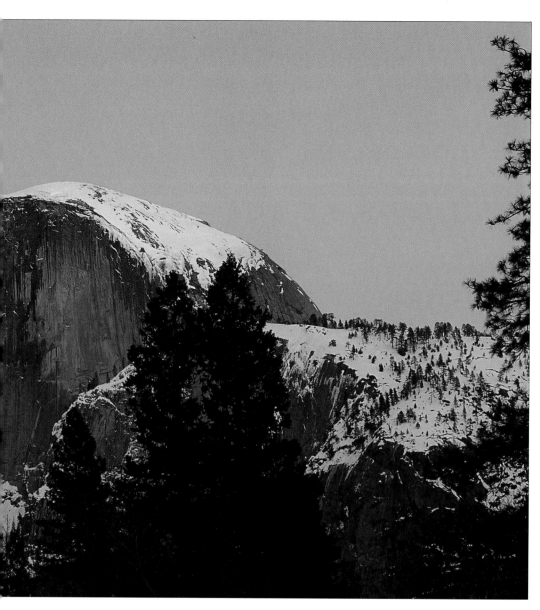

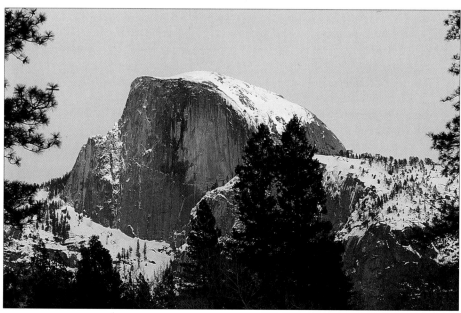

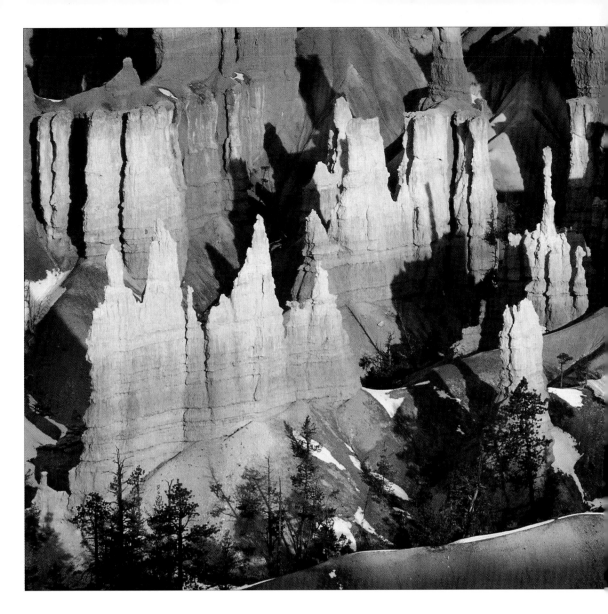

THE MOST STRIKING PHOTOGRAPHS of the
natural world tend to be taken early or
late in the day when the sun is low in the
sky. At these times, shadows cast by objects
lit by direct sunlight give a three-dimensional
feeling to a two-dimensional photograph.

After I had spent most of the day photo-
graphing bison and elk in Yellowstone
National Park, I paused to look at the snow-
covered scenery. At first, I was excited to
find a simple tri-coloured image of white
sunlit snow, grey snow in shadow and
blue sky, but then I noticed that it was
spoilt by the intrusion of a line of conifers
at the intersection of the three colour blocks.
As the road was on an incline, I walked
down it until I was able to mask the offend-
ing trees with the foreground hill by crouch-
ing down low on the ground. I had no
hesitation in choosing a horizontal format

for this shot because a vertical frame
would have included too large an area of
blue sky. The time of day is crucial to the
making of this picture, because the long
shadow created by a low-angled sun is
such an important element of the design.

Snow, shadow and sky
Yellowstone National Park, USA, February
Nikon F4, 70mm lens, Ektachrome 100 Plus

POINTS TO WATCH

● *If you find simple graphic elements, make
sure nothing else intrudes into the picture area.
For example, it is worth waiting for clouds or
vapour trails to disappear from the field of view.*
● *Look also for ripples on sand dunes to be
thrown into relief by their shadows cast early
or late in the day.*

Using Shadows

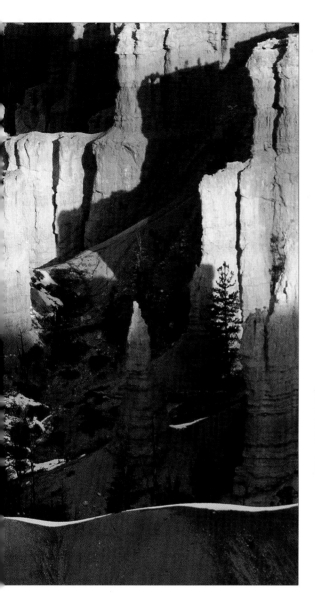

BRYCE CANYON, in Utah, is one of my favourite land forms. Because it is on a much smaller scale than the vast Grand Canyon, photographs of it seem much more immediate. I prefer working in the winter months when few people visit and the sun then transcribes a low arc thereby giving better modelling. Even so, the three-dimensional qualities of the eroded pinnacles are not apparent unless they are lit directly by sun early or late in the day when the shadows are most conspicuous. Known as Sunset Point, this particular view works best late in the day when the spotlit pinnacles project their shadows.

Eroded limestone pinnacles
Bryce Canyon, Utah, USA, January
Nikon F3, 200mm lens, Kodachrome 25

POINTS TO WATCH

● *Treeless land forms offer more scope for experimenting with different lenses and formats to gain the best possible composition for utilizing shadows to enhance geological features.*
● *From the air, low-angled sunlight grazing across a landscape helps to accentuate low profiles by the shadows it casts.*

Shadowless Lighting

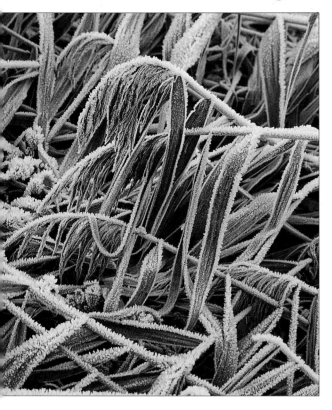

WHILE SOME SUBJECTS – notably landscapes – are enhanced by shadows, many others are better taken with shadowless lighting on an overcast day. Thick hoar frost, which forms overnight on objects when freezing fog occurs, persists only when temperatures remain sub-zero. I found these rime-covered reeds before the sun rose above the trees. The camera is calibrated to record a picture as an average tone, thus a reflected reading from a white subject will tend to underexpose it. I placed my grey rucksack (instead of a Kodak grey card) out of shot to meter the reflected light.

INTERTIDAL SEAWEEDS are exposed to the air and therefore accessible on foot for only a short time each day. I prefer taking seaweeds in overcast weather because plants on rocks are soon dried by sun and wind and turn a drab dark brown. This is why I try to find seaweeds in a rockpool bathed in sea water yet buoyed up by their air bladders. I set up the tripod legs straddling the pool with the film plane parallel to the water surface to ensure that the entire frame appeared sharply in focus.

Bladder wrack *(Fucus vesiculosus)*
Pembrokeshire, Wales, March
Hasselblad 500 C/M, 80mm lens + close-up
lens, Ektaachrome 64

Hoar frost on reeds *(Phragmites australis)*
Hampshire, UK, January
Hasselblad 500 C/M, 80mm lens,
Ektachrome 64

POINT TO WATCH

● *Make sure not to accidentally knock a tripod leg against the frost-covered plant you plan to photograph; this can so easily ruin the picture you first saw.*

POINTS TO WATCH

● *Check local tide tables for the timing of low water to make sure that you allow plenty of time for a safe retreat up the shore.*
● *Sea water is highly corrosive, so carry a small towel to dry your wet hands before handling equipment.*

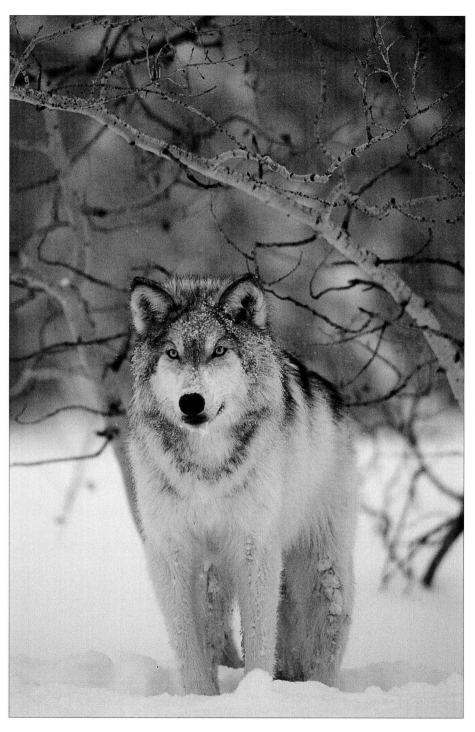

I WAS THRILLED with the way the aspen trunks echoed the buff and black tones of the wolf's coat and, once again, a dull day provided perfect lighting. There is no question that harsh shadows cast by direct sunlight would have spoilt this winter study. Instead, the harmonious muted colours enhance this eyeball-to-eyeball portrait of an animal shrouded in legend.

Wolf *(Canis lupus)* with aspens in snow (C)
Utah, USA, February
Nikon F4, 200-400mm lens, Kodachrome 200

POINT TO WATCH

● *When working in rain or snow, protect the lens and camera by draping a towel over it to absorb the moisture – but use discreet colours!*

Dusk and Dawn

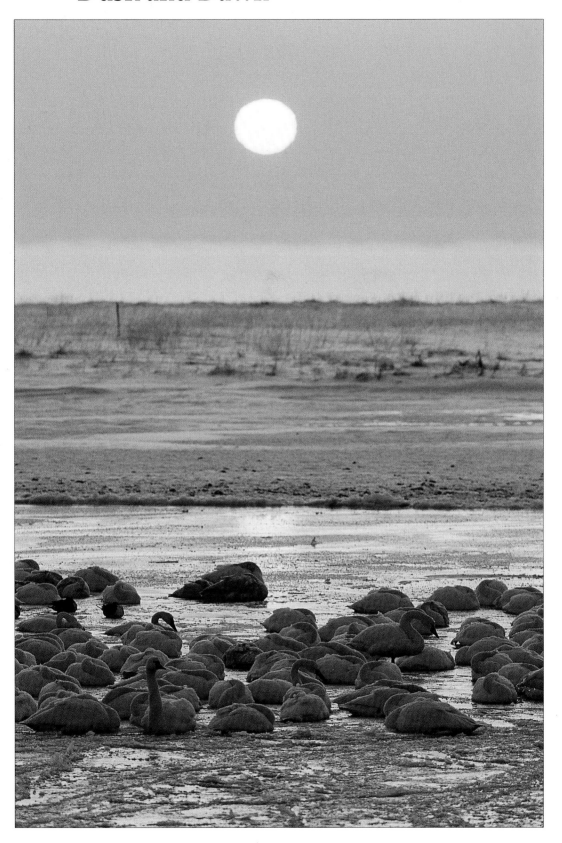

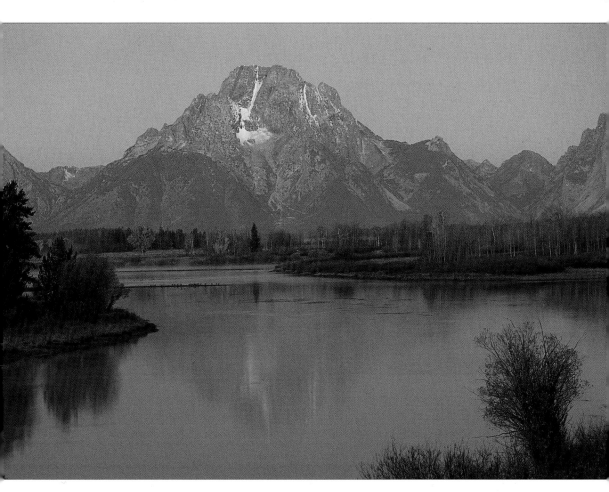

IT WAS STILL DARK when I set off for the Hokkaido coastline where whooper swans roost overnight. I had to work in deep snow, so I used a large plastic sheet to keep my rucksack snow-free. With the temperature at –25°C, I was glad I had covered the top tripod sections with foam pads and had brought a home-made woollen camera coat to insulate the body in use while I kept the other body warm inside my arctic anorak.

As the sun rose above the horizon, the colours were muted by a thin cloud cover, an effect which complemented the white swans covered with a dusting of snow.

Whooper swans (*Cygnus cygnus*)
Hokkaido, Japan, January
Nikon F4, 80–200mm lens, Kodachrome 200

● *At dawn in winter, it is important not to disturb wild animals before their bodies have had a chance to warm up. Stand back and use a suitable lens to show the animals in their natural setting – what I call my eco-pictures.*

DUSK AND DAWN can be magical times of day, although it is frustrating when a promising spectacle becomes obscured by clouds. I prefer working at first light because, unlike at the end of the day, I am not battling against falling light levels. Fortunately, on this occasion, there was no wind, because I had to use a one-second exposure with ISO 50 film to record the subtle alpen-glow falling on the peak facing the dawn sky and reflected in the water. It often pays to wait. Several photographers who arrived ahead of me left before the colour reached its peak.

Alpen-glow at dawn on Mount Moran
Grand Teton National Park,
Wyoming, USA, October
Nikon F4, 80–200mm lens, Fuji Velvia (ISO 50)

● *When visiting a well-known location, buy postcards to find the best viewpoints.*
● *Resist the temptation to mimic other photographers' work, however; instead, try to find a novel way of framing a famous landmark.*

Modifying Natural Light

MOST OFTEN I prefer to use naked, unfiltered lenses on my cameras, but there are times when available light needs to be enhanced by filtration. The filter I use most is a polarizer, to eliminate the skylight reflection from the surface of water and thereby enrich the colours of fish and submerged plants. It also increases the colour saturation of grass and leaves.
In addition, a polarizing filter enhances the contrast between white clouds (or flowers) and blue sky by darkening the latter.
The disadvantage of using this filter fully polarized is a loss of $1^1/_2$ stops, which can result in subject blur when taking moving elements with a slow film.

Faced with a colourless sky above a habitat, I use a grey graduated filter to decrease the contrast between the sky and the ground. Never, ever would I use the completely artificial-looking tobacco and magenta graduated filters much favoured by art directors for car advertisements. On overcast days I may use a warm-up filter to reduce a blue cast. When taking close-ups I can modify natural light by using reflectors or diffusers.

The river depicted here was invisible from the car, but when I got out and leant over the bridge I immediately saw the potential of the site. I knew that a wide-angle lens was needed to give foreground emphasis to the submerged aquatic plants and, because I did not want to crop the distant tree-lined banks, I opted for 20mm. All the ingredients were there – the band of marginal plants hugging the banks, crystal-clear water, fresh green leaves on the deciduous trees and a clear sky – to make this an idyllic lowland river scene.

From experience of shooting through water – both in rockpools as well as ponds and streams – I knew that a polarizing filter would be essential for eliminating the skylight reflection in the lower half of the frame and for increasing the colour saturation of the green leaves on both the submerged plants and the riverside trees. By using a small aperture (f11) I made sure that everything was in focus.

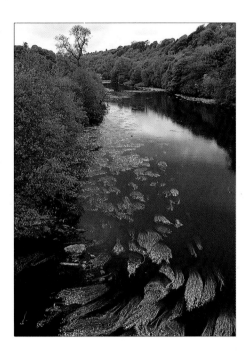

Although the photos were taken over a decade ago, the shot with a polarizing filter is still my favourite river picture and has been reproduced more than 20 times in books and magazines. The timing was perfect. If a storm upstream had poured silt-laden water into the river, the water had been turbulent, the sky overcast, or the trees had not yet leafed out, then the river would not have arrested my attention for a full hour. I doubt I shall ever see a river scene that matches it.

> **River Bandon**
> Inishannon, Ireland, May
> Nikkormat FTN, 20mm lens, Kodachrome 25
> Above: without a polarizing filter
> Right: with a polarizing filter

POINTS TO WATCH

● *Appraise a scene with and without a polarizing filter by holding it up to your eye and slowly rotating it.*
● *When using a graduated filter a square or rectangular-shaped kind, which can be moved vertically in its holder, is preferable to a screw-in filter which predetermines the position of the horizon in the picture.*

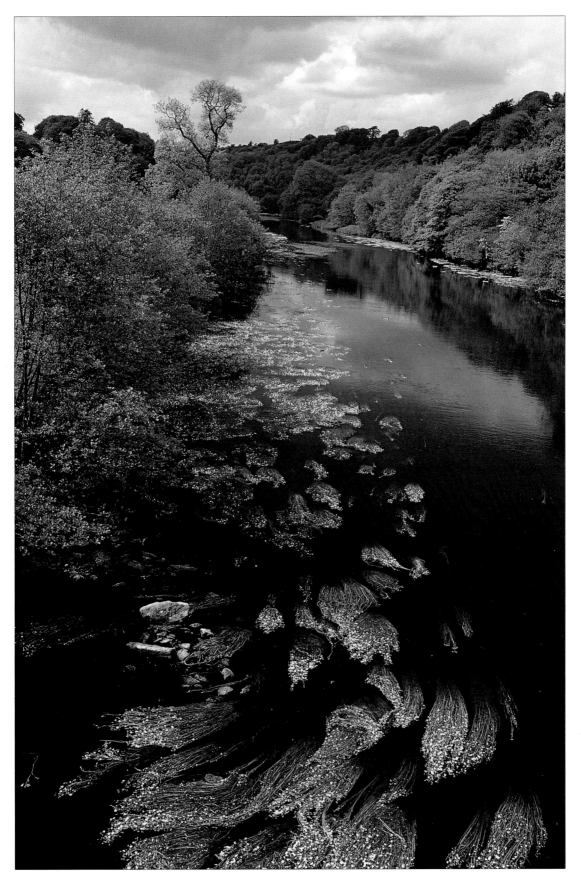

Fill-Flash

Fill-flash is an invaluable technique not only for lightening shadows but also for adding impact in dull light. The secret is to balance the flash exposure with the available light exposure. It should never look obvious that a day-time picture is taken with flash; use this technique only to enhance your pictures. A decade ago I had to scribble calculations on the back of a film pack; now, with the advent of dedicated flash guns which meter the light at the film plane, all I do is plug the flash into the camera, adjusting the flash exposure so that it under-exposes by about one stop on the daylight reading. Fill-flash can be used with any shutter speed at or below the fastest flash synchronization speed, but avoid low speeds if the subject is moving.

When I compared available light frames with fill-flash shots of this glory lily, it was obvious that the flash lifted the flowers from the background.

Glory lily *(Gloriosa superba)*
Masai Mara Reserve, Kenya, April
Nikon F4 and SB24 flash gun used as fill-flash,
105mm macro lens, Kodachrome 25

POINTS TO WATCH

● *Some flash guns can be used only in a fill-flash mode with the camera set on matrix metering; others allow spot metering. Make sure you check any limitations with your own model.*
● *Take comparative shots with and without fill-flash to see the merits of this technique.*

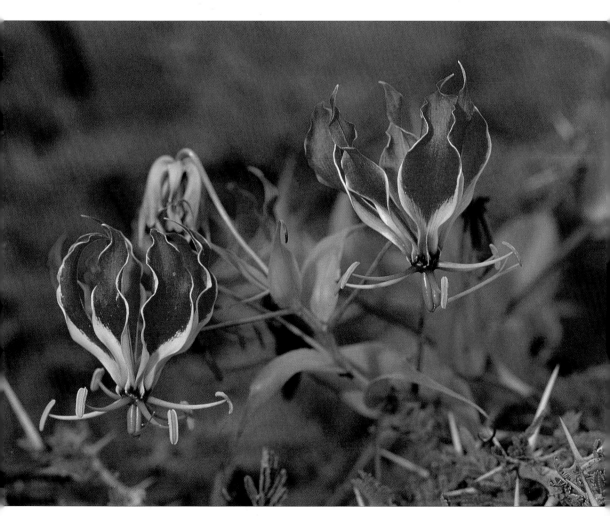

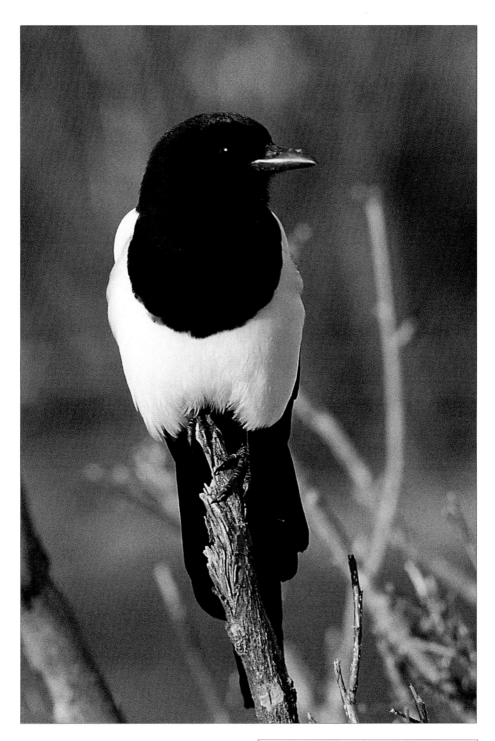

THERE IS NOTHING WORSE than taking a dark- eyed mammal or bird without any hint of a sparkle or catchlight in the eye, whether it be from direct sunlight or flash.

Many wild birds become tamer when they are attracted to food discarded at picnic sites. Even though it was mid-winter and no sane person was eating outside, once we stopped, magpies homed in on the car park. I was thankful I was carrying a flash so that I could make the dark eye – and hence the magpie – look more alive.

Magpie *(Pica pica)*
Yellowstone National Park, Wyoming, USA, February
Nikon F4 and SB24 flash used as fill-flash, 200–400mm lens, Kodachrome 200

POINT TO WATCH

● *Fill-flash on birds or mammals looks more natural on overcast days. If used in combination with sunlight, you may get twin catchlights appearing in the eye.*

Simple Silhouettes

THE NAME of this technique is derived from Étienne de Silhouette, a Frenchman who deftly cut profile portraits from black paper in the eighteenth century. This art is still practised today in China.

If photographic silhouettes are to succeed, they need to be simple, uncluttered images. The animal or plant should preferably be taken against a clear, brightly lit sky or, as in this case, against water.

Once all detail of surface texture is lost, the eye can concentrate on the shape of the animal or plant. For this reason, animals are best taken side-on so that distinctive features such as the shape of ears, length of tail, presence or absence of horns, neck or leg length are instantly recognizable.

Metering for a silhouette is easy, providing it occupies a relatively small area of the frame and there is considerable contrast between the subject and the background. By metering the bright background the subject will automatically be underexposed.

I try to take silhouettes using the glow of a sky at dawn or dusk (as shown here and on p.117). This helps to add impact to the silhouette, but at these times of day the light level may then necessitate using medium-speed film (ISO 200–400) in order to freeze moving animals, because all the impact becomes lost with a ghostly blurred silhouette.

Northern shoveler *(Anas clypeata)*
Lower Klamath NWR,
California, USA, January
Nikon F4, 200–400mm lens, Kodachrome 200

POINTS TO WATCH

● *Avoid having anything overlapping the main subject, since this will only confuse the perfect silhouette.*

● *Animals that are normally active at dusk and dawn in open habitats, such as the coast, in wetlands or deserts, are among the easiest to locate and photograph in silhouette.*

● *Bold, simple, branching plants – such as cacti and winter skeletons of trees – also work well as silhouettes.*

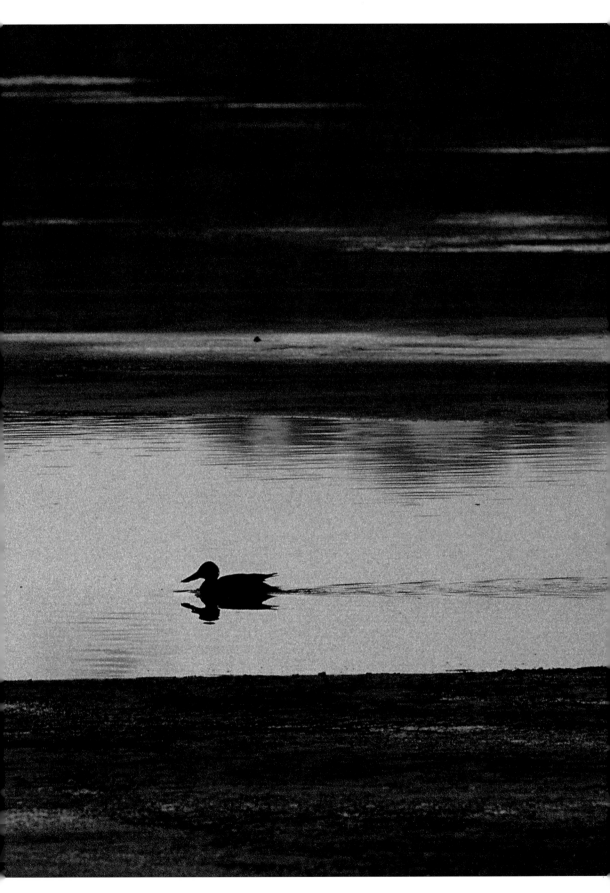

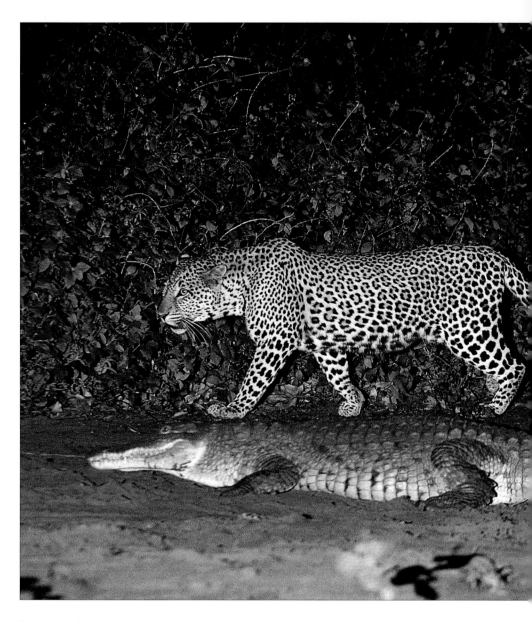

NOCTURNAL ANIMALS are much better adapted than humans to see and move around in the dark, so when it comes to photographing them we start off at a disadvantage. However, time spent looking for field clues and at the lie of the land in the vicinity of a nocturnal animal's home will help you to decide on the best way of tackling the photography. Since mammals have an acute sense of smell, either stand downwind of where they are likely to appear, use a vehicle or an elevated platform as a hide, or move away and trigger the camera with a remote controlled device.

To get pictures of rabbits feeding and running around at dawn (opposite), I parked on a lane-side verge overlooking a field. The rabbits took no notice of me moving inside the car, but whenever anyone walked down the lane they froze to the spot or bolted down their burrows. Flash was impractical for freezing action with a 600mm lens at first light; instead, I pushed Kodachrome 200 to 800 ISO. I was pleasantly surprised that the grain size was not more obvious.

Rabbit *(Oryctolagus cuniculus)* at dawn
Surrey, UK, May
Nikon F4, 600mm lens, Kodachrome 200
rated at 800 ISO

POINTS TO WATCH

● *Look for field clues, such as badger hairs on barbed-wire or deer tracks in mud, to discover routes currently used by nocturnal animals.*
● *Decide whether to push the film speed at first or last light, or to use a flash at night.*

The World at Night

THE ETHICS OF BAITING to attract nocturnal animals are dubious, especially if it leads predators to their prey. Nevertheless, a popular tourist attraction at a Kenyan game lodge is to observe crocodiles feeding on bait in a floodlit area. One evening, monkeys' alarm calls alerted me to the presence of a big cat. Moments later, a leopard emerged briefly before the crocodiles lunged at him. I skipped dinner to wait with the camera pre-focused on a tripod and was rewarded by a return visit, taking several frames before the leopard disappeared into the night. While I relished this unexpected photo opportunity, I appreciated how easily an agile wild cat could vault the low wall that separated me from the crocodiles.

Leopard *(Panthera pardus)*
Samburu, Kenya, April
Nikon F4 with SB24 Flash, 80–200mm lens,
Kodachrome 200

POINTS TO WATCH

● *Tape red cellophane over a torch, because nocturnal animals do not respond to red light.*
● *Glowing red eyes in mammals are caused by the flash being reflected back from the eyes. Avoid this by moving the flash off the camera.*

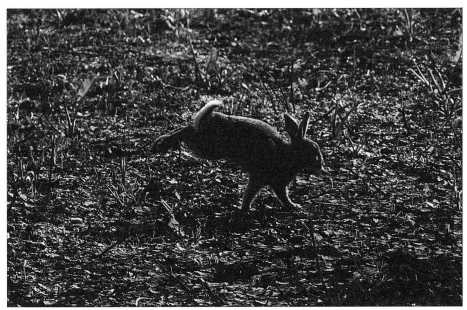

The Language of Colour

Colour is of prime importance to life on earth: plants use it to attract insect pollinators and to aid dispersal of their fruit; animals use it to attract mates, as warning signals to predators and as camouflage. The significance of colour to the natural world and the way we view it is the theme of this chapter.

COLOUR plays an important part in the survival of the natural world. Mottled colours disrupt an animal's body outline so that it blends with its surroundings; bright colours can attract a mate or warn predators against poisonous or nasty-tasting prey.

This is why I firmly believe that the natural world should, in general, be photographed in colour. Textured subjects are an exception: they can be most effectively reproduced in mono-chrome, when all the emphasis can be placed on the texture itself without the distraction of colour.

There is nothing subtle about red. Wherever it appears, a red object immediately attracts the eye. When focusing on pastel-coloured flowers watch out for red blooms behind; any red element – even out of focus – will be a distraction. Red flowers, such as poppies growing en masse, however, present endless opportunities. As is so often the case when working with the natural scene, the time of day (early morning) proved critical for the

picture opposite, not just for the low-angled light that accentuates the hairy stems and translucent petals, but also because poppies unfurl their petals at dawn. By the end of the day most have fallen to form a confetti-like carpet. In addition, freshly opened flowers with their pollen-laden stamens attract foraging bumblebees.

To convey the relative scale of the bees among the sea of red flowers, I opted to stand back with a long lens instead of using a macro set-up. I took several films, but the bumblebee in this frame was in the best position, hovering backlit above the poppy.

> **Poppies** *(Papaver rhoeas)*
> Surrrey, UK, June
> Hassselblad 500 C/M, 250mm lens,
> Ektachrome 100 Plus

POINT TO WATCH

● *When working with red flowers, consider carefully the proportion of red within the frame. A single red bloom among, for example, green ears of corn can be a most effective way of leading the eye to the flower.*

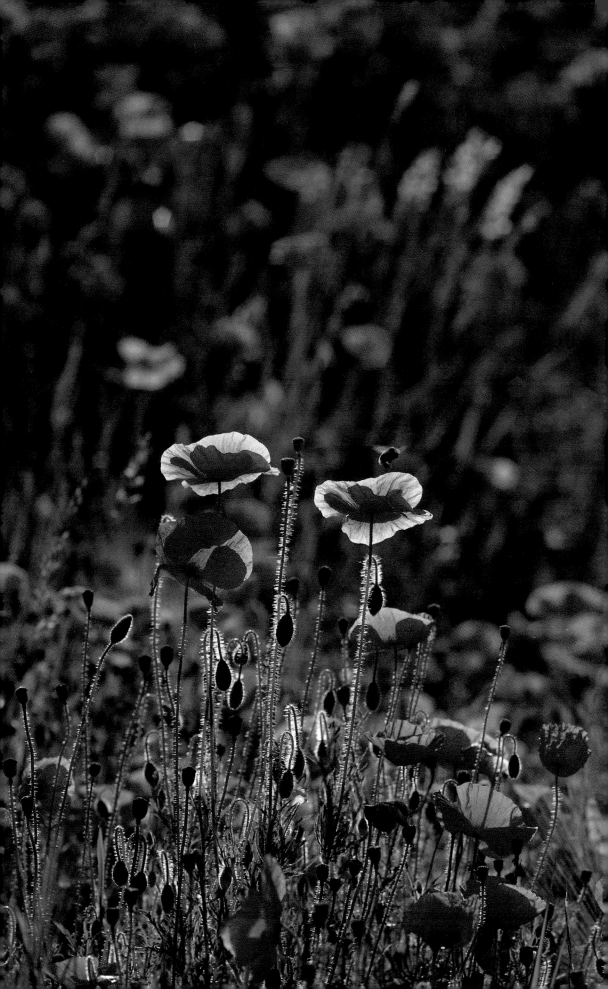

Muted Colour

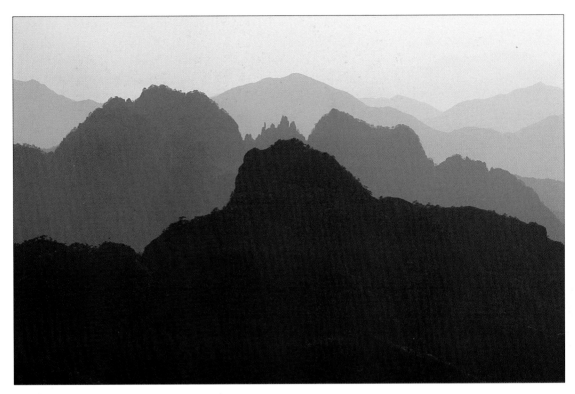

MUTED COLOURS abound in nature: in rocks and sand, in pastel-coloured flowers and feathers. In addition, all colours and tones are muted by soft shadowless lighting, by rain, mist and falling snow.

When a series of hills or mountain ranges are viewed in hazy conditions (caused by dust or mist) against the light early or late in the day, the colours (or tones if in silhouette) appear fainter with each successive range. This gradation of recession planes can be emphasized still further by using a telephoto lens to compress the distances. Huangshan is a famous Chinese mountain that has inspired photographers and artists alike.

DURING WINTER in Yellowstone, the weather can change quickly. As I was photographing a frozen waterfall, the adjacent rock colours were enriched by the low-angled sun. Bent over my camera, I heard a Clark's nutcracker begin to call from a tree beside me (bottom right). By the time I had replaced a wide-angle lens with a telephoto zoom and framed the shot, it had begun to snow; but, in the event, this helped to accentuate the muted tones of the grey feathers and also to blot out the rock cliffs behind.

Clark's nutcracker (*Nucifraga columbiana*)
Yellowstone National Park,
Wyoming, USA, February
Nikon F4, 200–400mm lens, Kodachrome 200

Recession planes at sunset
Huangshan, Anhui Province,
China, October
Nikon F3, 135mm lens, Kodachrome 25

POINTS TO WATCH

● *If the weather is cold and overcast but not misty, you can create a temporary misty effect simply by breathing on the lens.*
● *Snow and rain can damage electronic circuitry, so protect the camera by draping a towel or holding an umbrella over it. If moisture does get inside a lens, use a hair dryer to dry it out.*

POINT TO WATCH

● *Research possible vantage points for taking mountain ranges at dawn or dusk by looking at postcards, books or contours on maps.*

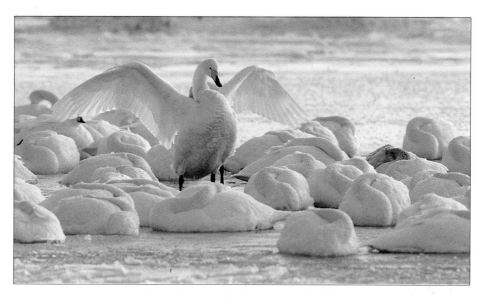

THE APPEARANCE of massed white swans changes with the weather and the light; compare this picture with the one on page 38, taken less than an hour earlier at the same location. I particularly like the nuance of the picture above where none of the birds is reacting to the two swans (note the three black legs) that have woken up and are flexing their wings in readiness for an active day ahead.

Whooper swans *(Cygnus cygnus)*
Hokkaido, Japan, January
Nikon F4, 200mm lens, Kodachrome 200

POINT TO WATCH

● *If overnight snow is forecast, it is worth visiting a waterfowl roosting site at dawn the next morning, since the coloration of any birds will be muted by a dusting of snow.*

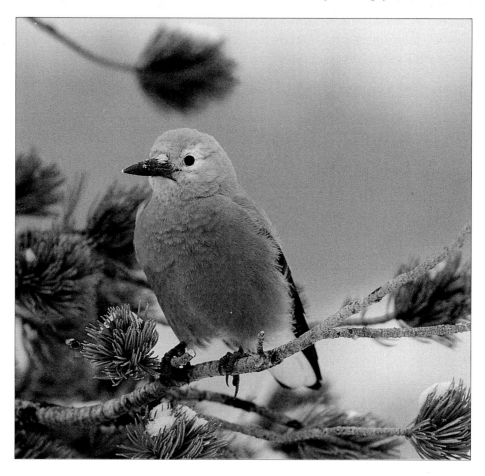

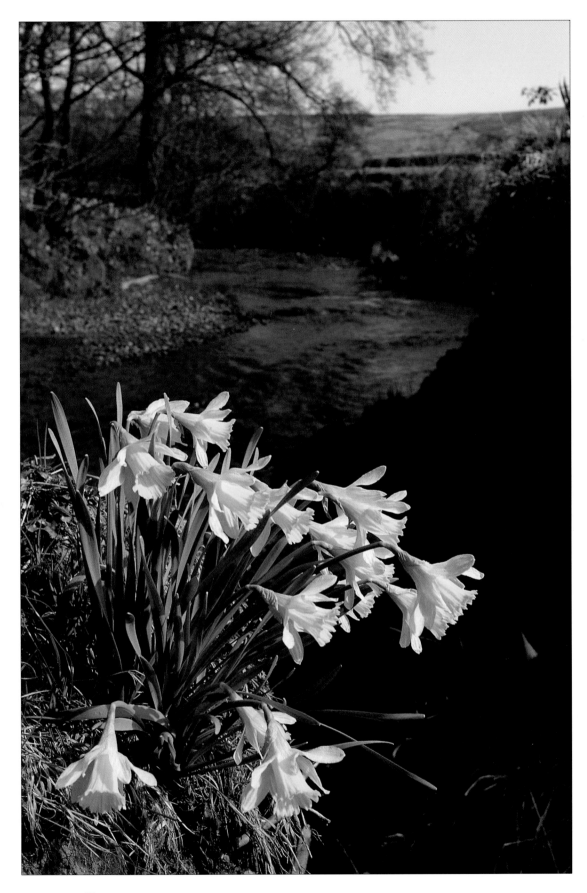

Contrasting Colour

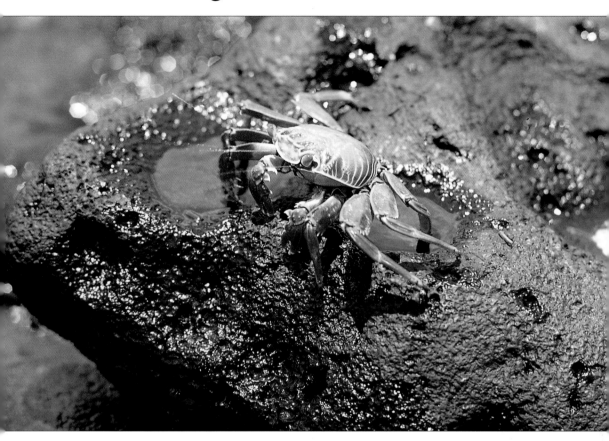

NATURAL COLOURS which give the strongest colour contrast are red and green (a red flower among green leaves), or red and blue (a red flower or fruit against a blue sky or a red fish in blue water). Yellow flowers or birds look dramatic when seen against a blue sky enhanced with a polarizing filter. However, any plant or animal sporting a saturated colour viewed against drab surroundings will provide a striking contrast. To witness wild daffodils carpeting the ground on either side of a river is a thrill in itself, but when the sun burns through a light cloud cover to backlight a clump of yellow flowers, it is magical.
It did not take me long to find a viewpoint where I could exaggerate the colour against an unlit part of the river bank, yet still include part of the river.

RED ROCK CRABS scuttle over the rocks with great agility just above the crashing surf. On any shore, they bring spectacular mobile colour, but the colour contrast is even better on beaches where there are black volcanic rocks. By crouching low and waiting for a crab to scuttle towards me, I was able to get many shots. Only after processing did I realize that I had caught, on just one frame, the moment when the crab ejects water from its gill chamber.

Sallylightfoot crab (*Grapsus grapsus*)
Isla Isabela, Galapagos Archipelago, March
Nikkormat FTN, 135mm lens,
Kodachrome-X (ISO 64)

POINTS TO WATCH

- *Use backlighting to increase the vibrance of colourful petals or leaves viewed against a neutral background or a shadow area.*
- *Late in the day, front lighting can be very dramatic. It also enhances warm colours.*

Wild daffodils (*Narcissus pseudonarcissus*)
Farndale, Yorkshire, UK, April
Nikon F3, 35mm lens, Kodachrome 25

Purposeful Colour

MANY ANIMALS that are active by day and have good colour vision use eye-catching colour signals to communicate in a variety of ways, all of which, directly or indirectly, aid their survival in the wild. When conspicuous colours are combined with a sting (wasp), poisonous secretions (arrow poison frogs) or a foul smell (skunk), they serve as warning colours to predators to leave well alone. Typically, warning colours in nature appear as yellow/black, red/black, red/yellow/black or white/black combinations.

Many male birds display colourful parts to attract a mate; for example, blue- and red-footed boobies display their coloured feet to reinforce their pair-bonding. I took the picture below of the yellow-headed blackbird in a drive-through wetland reserve using the car as a hide, with the camera mounted on a window clamp.

Yellow-headed blackbird
(Xanthocephalus xanthocephalus)
Lee Metcalf NWR, Montana, USA, June
Nikon F4, 200–400mm lens, Kodachrome 200

POINT TO WATCH

● *When photographing an animal that uses shock tactics, take a pair of pictures, one to show it at rest and the other displaying.*

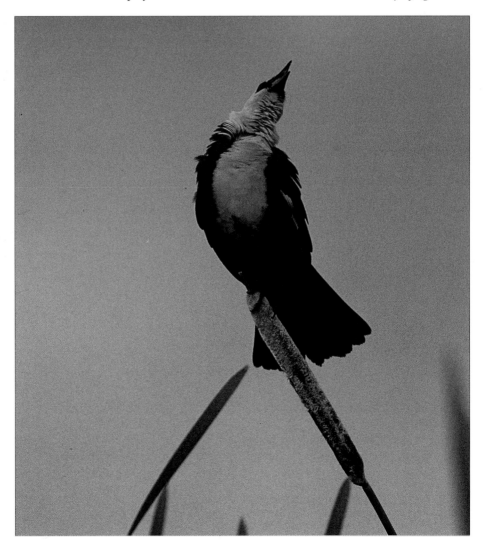

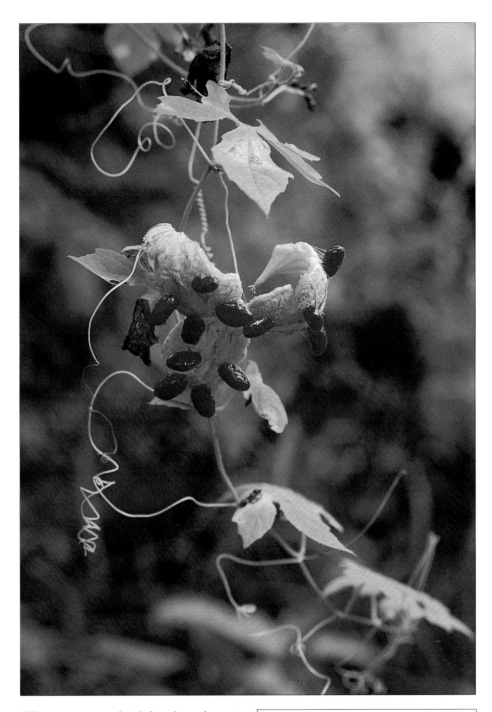

PLANTS, TOO, are brightly coloured – not simply to provide attractive subjects for nature photographers, but to lure insects to pollinate their flowers or animals to feed on, and thereby disperse, their fruit.

The fruit of the tropical climber above gradually turns from green to orange. When ripe, it splits open to reveal the highly attractive bright red seeds inside. In any light, the vibrant colours naturally separate from the muted background.

Tropical climber (*Mormordica charantia*) with ripe dehisced fruit
Isla Santa Cruz, Galapagos Archipelago, March
Nikkormat FTN, 135mm lens,
Kodachrome-X (ISO 64)

POINT TO WATCH

● *Try to anticipate when a colourful fruit is ready to split open, because the interior is rapidly feasted upon by opportunist animals.*

Natural Camouflage

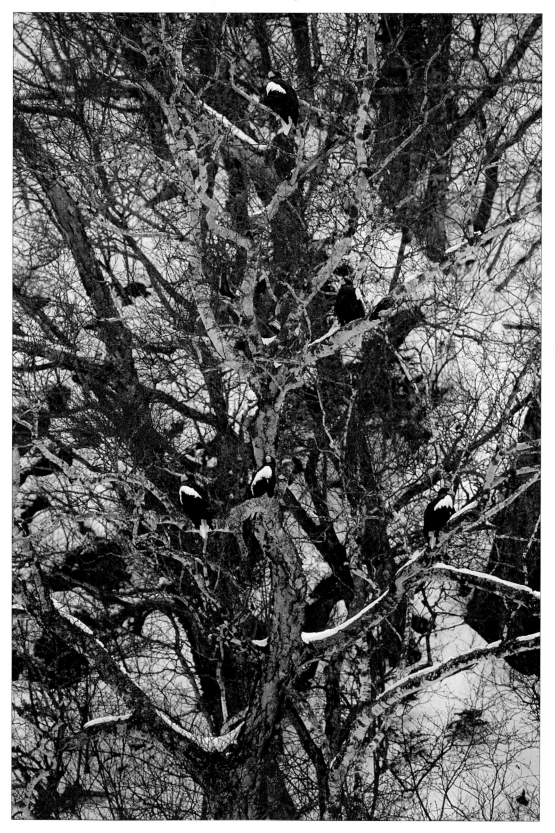

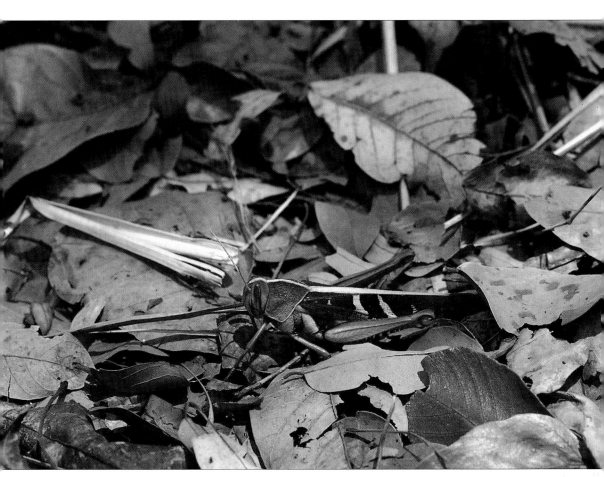

CAMOUFLAGE COLOURS work in a similar way to camouflage clothing; they break up the body outline, making it difficult to detect. In sunlight against a blue sky, a mature Stellar's sea eagle is a spectacular bird with brown plumage, white-edged forewings and a yellow bill, so I was intrigued to discover five birds perched in a roadside tree, well camouflaged after a snowstorm. I knew that the birds would be using trees as perches so I scanned every one we passed and the yellow bills caught my eye. As my Japanese, non-English-speaking driver had already ruined my first attempt to photograph these birds by suddenly opening his door, I grabbed his shoulder and gesticulated that he was to stay put! I used the car as a hide with the camera mounted on the versatile Benbo tripod.

WHILE SEARCHING for a chameleon to photograph, I sensed this grasshopper out of the corner of my eye as it leapt away from my advancing feet. So well camouflaged was the reddish-brown body streaked with yellow, resting among fallen leaves and dry grasses, that it took me several minutes to relocate it. I deliberately kept the insect quite small in the frame, because the significance of camouflage becomes apparent only when the animal is seen in its natural surroundings.

Short-horned grasshopper *(Nomadacris septemfasciata)* **among leaves**
Ndola, Zambia, August
Nikon F3, 105mm macro lens, Kodachrome 64

POINT TO WATCH

● *To illustrate animal camouflage successfully, it is preferable to use available light. Avoid using direct flash, since this may produce telltale shadows, thereby counteracting the animal's attempts to blend in with its surroundings.*

Stellar's sea eagles *(Haliaeetus pelagicus)*
Rausu, Hokkaido, Japan, January
Nikon F4, 600mm lens, Kodachrome 200

Iridescence

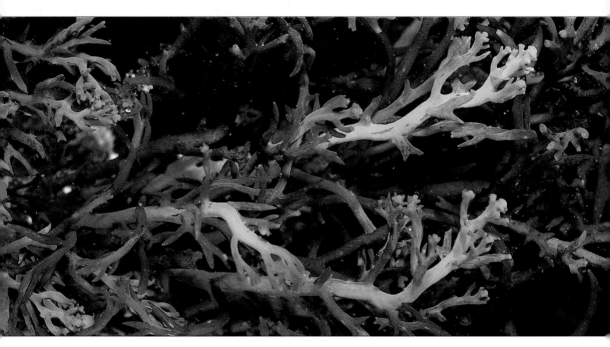

METALLIC-LIKE COLOURS that change depending on the angle from which they are viewed are known as iridescent colours. They arise as a result of the interference of light wavelengths, some of which are reflected from the surface and some from minute particles inside.

Iridescence occurs among feathers, shells, insects and even a few plants, including some seaweeds. The beautiful blue/green colours on the seaweed above can be seen only when it is underwater; in air it reverts to the typical colour of brown seaweeds. I took this picture by shooting through the water using a flash at 45° to the surface (so that it would not be reflected back from the water) to boost the exposure and thereby increase the depth of field.

A COURTING PEACOCK, with his glorious erect tail fan of shimmering metallic-coloured feathers, is surely one of nature's great spectacles. I like to photograph iridescent colours using available light if possible so that I can see precisely the way they will appear on film. Otherwise, unless you use a flash with a built-in focusing light (or tape a torch to the side), it is difficult to visualize the end result.

I taped this feather to a velvet-covered board, propped up against a chair so that the sun shone directly onto the feather.

Peacock (*Pavo cristatus*) feather
Surrey, UK, June
Nikon F4, 200mm macro lens,
Fuji Velvia (ISO 50)

Iridescent seaweed (*Cystoseira tamariscifolia*)
Cornwall, UK, March
Nikkormat FTN, 55mm macro lens,
Kodachrome–X (ISO 64)

POINT TO WATCH

● *When shooting down through water, mask all chrome parts on the camera and tripod with matt black tape, so that no distracting reflections appear in the water surface.*

POINTS TO WATCH

● *Observe the effect of changing the light source relative to the viewing angle by placing a feather on the floor of a dimly lit room and moving a torch (or portable lamp) whilst viewing from overhead.*
● *When photographing iridescent shiny-winged beetles avoid using direct light, because it will reflect as a bright spot; instead, use a diffuser to soften the light.*

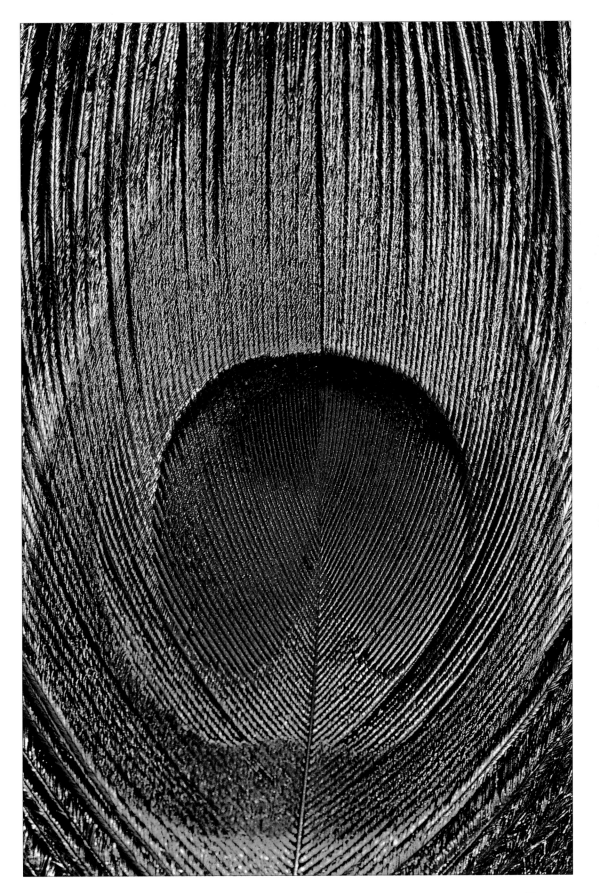

Abstract Colour

ABSTRACTED IMAGES of the natural world can be found on both grand and small scales. Wherever I work, I keep a watchful eye for possibilities. Both these pictures exemplify the point that many graphic images – not perhaps immediately discernible – can be extracted from a broad vista by using a long lens. Simplicity is generally the key to successful abstract pictures – the fewer the elements the better.

Over the last two decades I have spent many hours in boats, either getting to remote islands or simply waiting for whales or dolphins to surface. It is all too easy to sit watching the sea surface with your eyes set on non-focus mode, as it were. I, too, was guilty of this until I noticed how the inter-play of light on water offered exciting possibilities – whether frozen with a fast shutter speed or blurred with a slow one.

I saw this abstraction – cliffs reflected in blue water – when we dropped anchor in the Sea of Cortez. The horizontal lines of waves dictated the format and composing the picture was easy with a telephoto zoom lens – although no two frames were identical.

Cliff reflected in water
Sea of Cortez, Baja California, Mexico, March
Nikon F4, 80–200mm lens, Ektachrome 100

POINTS TO WATCH

● *Look for abstracts in ripples on sandy beaches, reflections in water distorted by surface ripples or the polygonal shapes which appear when mud dries out.*
● *Tall-stemmed flowers blowing in the wind can be abstracted by using a slow shutter speed to blur the blooms.*

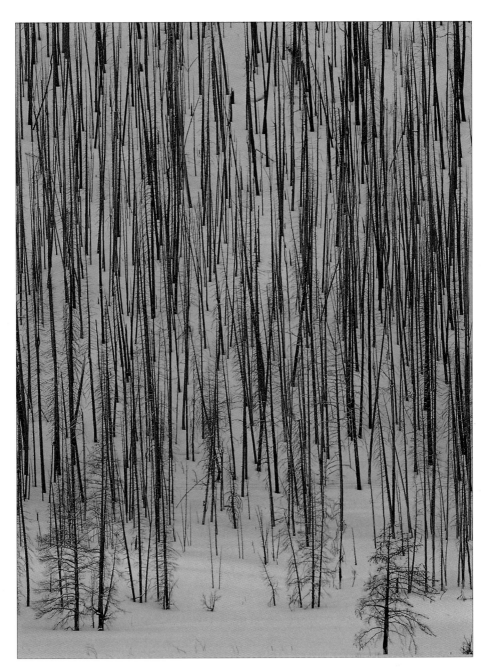

THE REPETITION of dark lines against a white background makes this essentially monochromatic picture. Taken in winter, it depicts a stand of dead lodgepole pines thrusting up from a deep blanket of snow. Two factors – one positive, one negative – have helped to distil the image into a simple uncluttered one: the snow blankets the multifarious shapes and colours on the ground, while the absence of sun meant that no shadows were cast across the snow. Without snow or with sun, the picture would not have been worth taking. Because the area of burnt trunks approximately equalled the area of snow, I used the matrix reading given by the camera. If there had been a greater proportion of snow I would have opened up a half to one stop on the matrix reading.

Dead lodgepole pines
(Pinus contorta var. latifolia)
Yellowstone National Park,
Wyoming, USA, February
Nikon F4, 200–400mm lens, Kodachrome 25

Working with Weather

No one can control the weather, but seemingly adverse conditions can provide some stunning photo opportunities. The pictures in this chapter illustrate how particular weather – such as mist, rain, snow or wind – can be exploited to the full. In addition, the problems of working in climatic extremes from the Arctic to the tropics are outlined.

IF THE ATMOSPHERE remained static and unheated, we would experience no change in the weather and, although we persistently complain about it, how boring that would be for photographers. For me, one of the delights of working out in the field in different climatic zones in all seasons is the variable weather conditions I experience.

Temperate regions have a varied and changeable climate. Although the mean summer temperatures are consistently warmer than the mean winter temperatures, unpredictable freak weather may occur at any time of year. For example, on the night of 15/16 October 1987 south-east England experienced gale force winds that felled 5 million trees overnight, and gave me unique photo opportunities for recording wind-blow damage – both from the ground and up in the air from a hot air balloon. Total cloud cover reduces the available light for photography, which may be ideal for taking pastel-coloured flowers, but it lacks the atmosphere of misty conditions. Mist forms at night when warm,

moist air comes into contact with cooler ground or mixes with cold air, so early morning is the best time to look for misty scenes, before the sun has a chance to burn through.

In Japan, one troop of macaque monkeys enjoys bathing in pools fed by hot springs that steam early in the morning. When I was there, the exposure reading constantly changed as the wind wafted the steam back and forth, so I used the automatic shutter priority mode. I picked the most atmospheric moment when the mist created a soft-focus portrait of the monkey.

Japanese macaque *(Macaca fuscata)*
Shiga Heights, Japan, April
Nikon F3, 200mm lens, Kodachrome 200

POINTS TO WATCH

● *Check weather forecasts for localized weather conditions, such as mist, for gaining atmospheric photographs.*
● *When a cold camera is exposed to a hot, humid atmosphere, the lens will steam up, creating an ephemeral mist which can be used as a substitute for a soft-focus filter.*

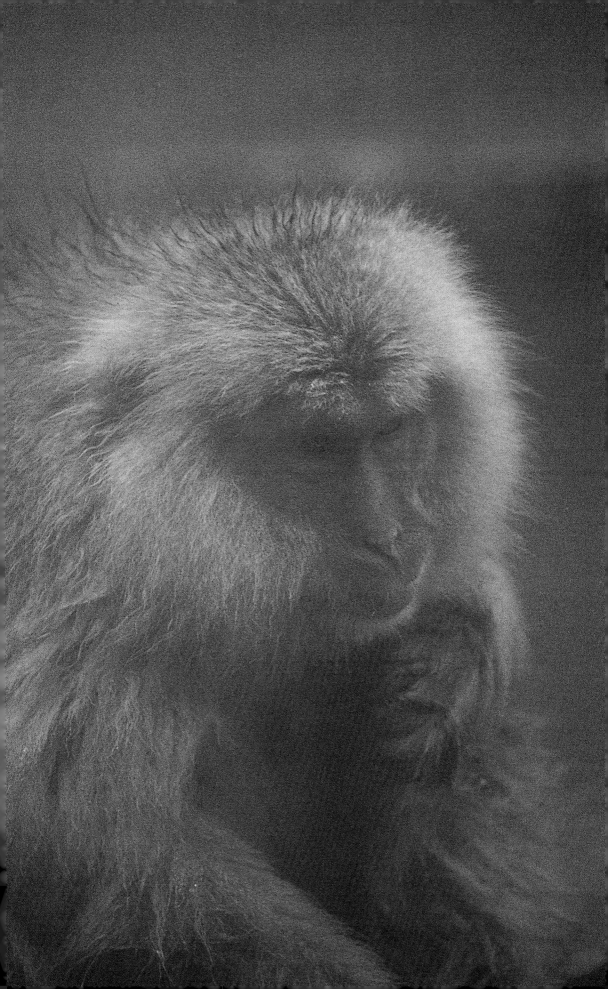

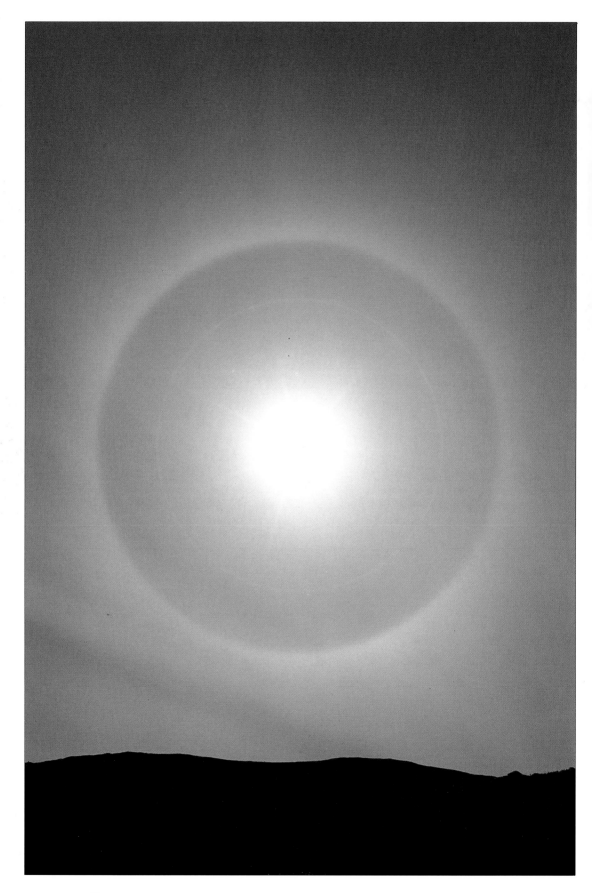

The Atmosphere

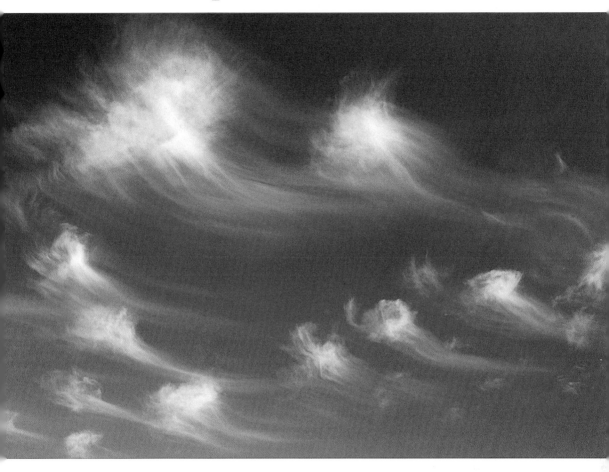

I N THE STRIKING PHOTOGRAPHS of earth from space, we see the envelope of gases that surrounds the earth – what we call the atmosphere – as a mix of clear sky and swirling clouds. Indeed, these satellite photographs are now an indispensable tool for accurate long-term forecasts – so essential for photographers planning a trip. I saw the complete halo around the sun whilst trekking in Greenland. This optical phenomenon is caused by the refraction and reflection of light by ice crystals in thin cirro-stratus clouds. To include the complete halo I set my widest angle lens on infinity. The framing was checked with the camera on a tripod, so that I looked directly at the sun for only a brief moment.

A S AIR RISES, it cools and condenses into tiny water droplets, forming fog and clouds. Solid cloud blots out light, whereas sparse cloud can add drama. Many of my cloudscapes are composed with a narrow sliver of land or sea at the base of the frame to give a sense of permanence to the picture. When striking clouds develop well above the horizon, however, then I exclude it. Reminiscent of jellyfish with trailing tentacles, these clouds were enhanced with a polarizing filter to darken the blue sky.

Cirrus clouds
British Columbia, Canada, July
Nikon F4, 35–70mm lens, Kodachrome 200
polarizing filter

Halo around sun
Greenland, July
Nikon F3, 20mm lens, Kodachrome 25

POINT TO WATCH

● *Consider and compose cloudscapes as distinct from landscapes.*

Wind and Rain

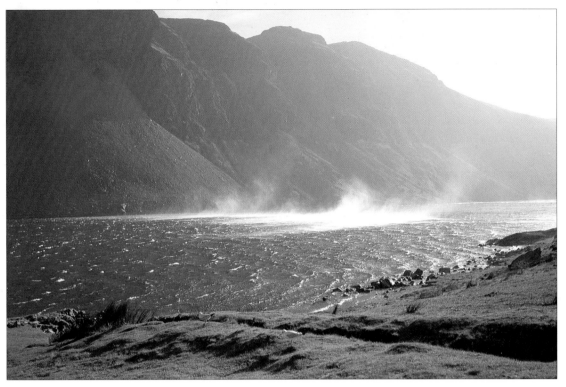

PERSISTENT WIND OR RAIN creates many a headache for the nature photographer; windy days strain the patience of anyone intent on taking tall-stemmed plants, while rain can play havoc with electronic circuitry. Nowadays, however, I no longer adopt a negative attitude towards wind and rain. Instead, I actively search for pictures created by these inclement elements – pendulous branches of trees blowing in the wind, for instance, or coastal trees misshapen by the effects of wind-pruning or magical silver raindrops.

The picture above depicts a freak weather phenomenon: strong winds carrying surface water vertically into the air. The wind was so strong that it blew my tripod over – luckily before I secured the camera. The sombre hills proved an ideal contrast to the white spray, while the shoreline mirrors the hill profile.

GIVEN LOW LIGHT, I like to convey rain falling as a series of streaks by using a slow shutter speed. The red leaves (bottom right) caught my eye and I thought I could get away with taking a few frames with an unprotected lens by standing beneath the trees. I hurriedly packed my gear away and only later discovered that water had caused the lens to fog up inside. I spent the next hour rotating it beneath the heater inside our jeep as we drove to the next location in the searing tropical heat! Gradually the condensation inside the lens evaporated.

Rain falling on *Terminalia* leaves
Parque Nacional Manuel Antonio,
Costa Rica, April
Nikon F4, 80–200mm lens, Kodachrome 200

POINTS TO WATCH

● *Use a slow-speed film (or a neutral density filter with a faster film) to gain a slow shutter speed to record raindrops falling as streaks.*
● *Look for radiating ripples made by raindrops falling into calm, open water.*

Wind blowing surface water off lake
Wastwater, Lake District, UK, November
Hasselblad 500 C/M, 60mm lens,
Ektachrome 64

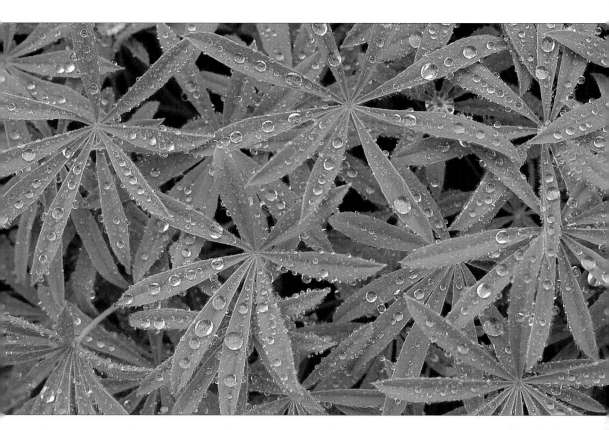

I WOULD NOT NORMALLY have chosen to venture outside while it was raining so persistently but, because I was abroad, I objected to wasting time sitting indoors. The raindrops on young hairy lupin leaves (above) glistening like jewels on the forest floor were inviting me to take them. To make sure that the camera, at least, was kept dry, I set it up on the tripod and covered it with a made-to-measure Camera-mac (which allows me access to the controls).

As the rain was particularly strong, I also held a clear plastic umbrella over the camera. In this instance, the gamble of using a one-second exposure paid off and the leaves were not blurred by falling rain.

Raindrops on lupin (*Lupinus* sp.) leaves
Bitteroot Mountains, Montana, USA, June
Nikon F4, 105mm macro lens,
Fuji Velvia (ISO 50)

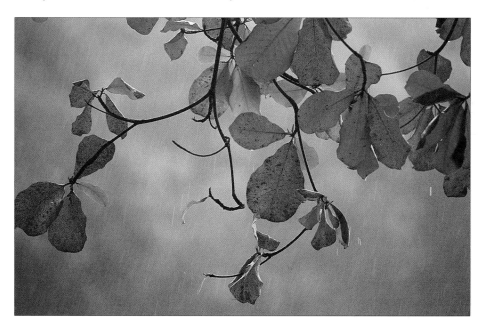

Using Mist

MIST AND FOG CLOUDS develop at the earth's surface when warm air either mixes with cold air or comes into contact with colder ground. Mist need not be a drawback; indeed I value it greatly when it creates atmosphere in a picture. It can also be used to blot out man-made eyesores in a wilderness scene.

Cranes have for long been regarded as sacred birds in Japan, but Hokkaido farmers, convinced that the cranes were depleting their corn stock, reduced their numbers on this island to a mere 33 by 1952. Now protected, these elegant birds have gradually increased in numbers.

When I arrived at first light beside a river where Japanese cranes roost overnight, the temperature was positively arctic, but there were already several dozen tripods on the bridge. This number soon mushroomed when a photo tour emerged from a coach and it became hard to find room for just one more.

At first, the river was completely blotted out by mist rising as fluffy clouds from the warm water, but trees lining the river, coated with a thick hoar frost, provided a classic winter scene. After an hour, the mirrors on both my Nikon F4 bodies locked – despite the fact that I was using lithium batteries capable of working down to -20°C. Fortunately I always carry some chemical handwarmers for cold-weather work and one slipped inside a fleecy camera coat did the trick.

Gradually, as the mist thinned out, the ghostly figures of cranes in the river began to emerge. As the warmth of the sun's rays reached them, the birds became more active and started to preen themselves. Suddenly they turned to face the same direction, gracefully lifted off and were gone. The waiting time had far exceeded the shooting time, but the preparation more than paid off.

Japanese cranes (*Grus japonensis*)
Setsuri River, Hokkaido, Japan, January
Nikon F4, 600mm lens, Kodachrome 200

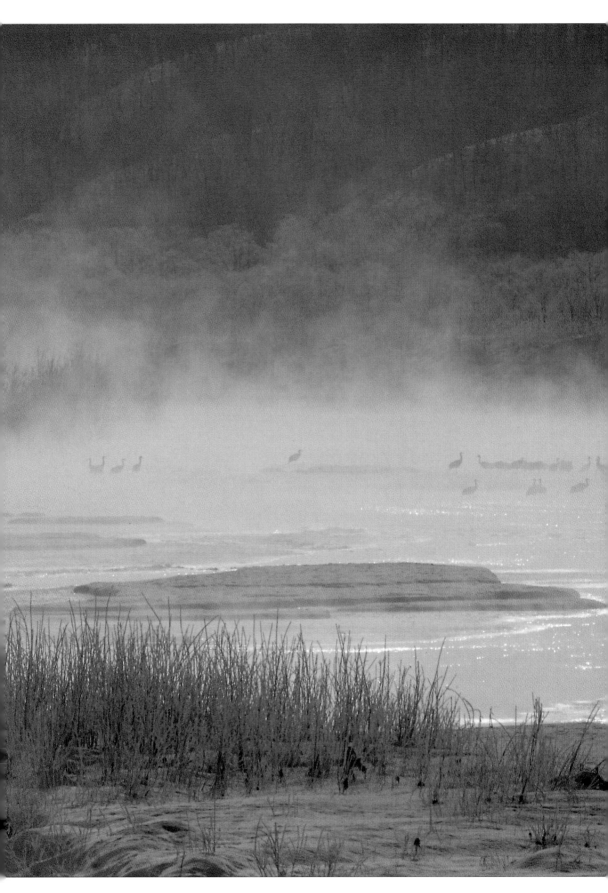

Arctic Conditions

Batteries are the life blood of electronic cameras; if they fail the camera is unusable, yet intense cold means death to most batteries. For the picture below, I used a remote cold-weather battery pack inside my anorak. Now I use lithium batteries (which work down to –20°C), a woollen camera coat and carry chemical hand-warmers to keep spare batteries warm.

The mother seal and pup were taken at the same location as the pup on page 125, but when a blizzard blew, we had to stay put because we could not distinguish thin ice from safe thick ice. Note how the mother's eye secretions have melted the otherwise snow-caked face. The lack of contrast between the animals and the snow-covered ice made focusing difficult.

On days when the sun shines, so much light is reflected from the snow and ice that slow-speed films can be used. The temperature remains below freezing when the sun is out, but it was much easier to focus on this polar bear than on days when the wind blew and made my eyes water. The bear sat on the ice long enough for me to take half a roll, but kept moving his head from side to side, so I only shot a few frames with him looking at the camera.

Polar bear (Ursus maritimus)
Cape Churchill, Canada, November
Nikon F3 with cold-weather battery pack,
300mm lens, Kodachrome 64

POINTS TO WATCH

● *In cold weather, film becomes brittle and can easily tear. Therefore, rewinding by hand is preferable to using an automatic rewind.*
● *Insulate metallic tripod legs with Tri-pads or foam strips used by plumbers on pipes.*

Harp seal (Phoca groenlandica)
Gulf of St Lawrence, Canada, March
Nikon F3 with cold-weather battery pack,
200mm lens, Kodachrome 200

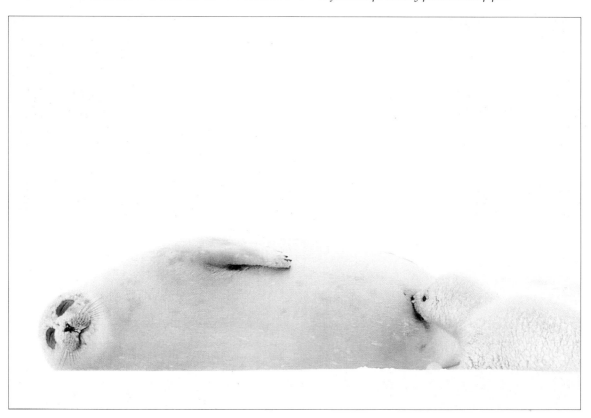

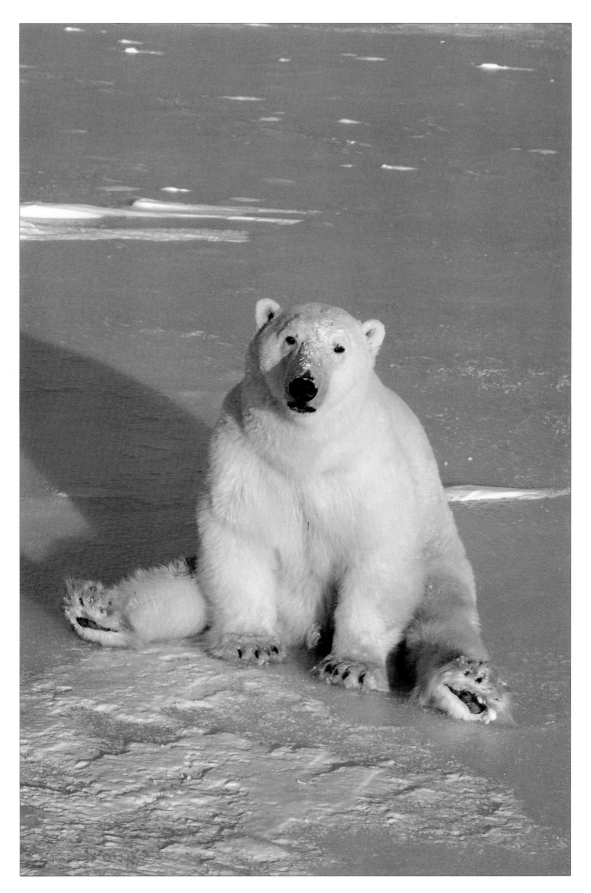

The Tropics

Pᴇʀꜱɪꜱᴛᴇɴᴛʟʏ ʜᴏᴛ and humid conditions in tropical rainforests may be ideal for supporting the most species-rich of all habitats, but unless special precautions are taken they can be detrimental to both cameras and film.

I store all film, both unexposed and exposed, in airtight boxes with dry (blue) silica gel crystals. These turn pink on absorbing moisture, but can be dried out again by gentle heating. Because modern electronic cameras are susceptible to failure if moisture gets inside, I take various precautions. I use a clear plastic umbrella to protect the camera on a tripod in rain and I carry a towel for mopping up water on the outside of equipment, as well as a variety of made-to-measure camera macs. As a precaution against water shorting out flash connectors, I cover them with small strips of waterproof tape.

There is always a wealth of subjects on a rainforest floor, but it is worth pausing to look up towards the canopy for a novel viewpoint. I did just this in Costa Rica

and found the sunlight beaming through freshly opened leaves. By using a long-focus lens and shooting skywards, I was able to isolate the glowing leaves from neighbouring trees lit by indirect sunlight. I spot-metered the light shining though one of the leaves.

New leaves on tree
Monteverde, Costa Rica, April
Nikon F4, 300mm lens, Kodachrome 25

POINTS TO WATCH

● *A pale-toned gadget bag will reflect light (and heat) better than a black or navy one.*
● *Leaf litter abounds with insects and other animals, so carry all spare equipment in a waist pouch rather than leaving your gadget bag on the ground.*
● *Wear sweat bands on head and wrists and place one on the focusing ring of a long-focus manual lens to stop sweaty hands from slipping.*
● *Use a waterproof notebook and pencil for taking notes.*

ON OCCASIONS, overcast skies can be a bonus when working inside rainforests, because the light will be less contrasty than on a sunny day.

As soon as I saw this scarlet macaw, I knew it would be a race against time for me to set up my camera on a tripod, spot-meter through an adjacent green leaf and compose the picture before the bird moved on. Fortunately, it was so intent on eating a fruit that it remained on the same branch long enough for me to shoot an entire roll. However, since the light level was low, I had to use shutter speeds of 1/60 and 1/30 second and pick moments when the bird was least active.

> **Scarlet macaw *(Ara macao)***
> **feeding on *Terminalia* fruit**
> West coast, Costa Rica, April
> Nikon F4, 300mm lens, Kodachrome 200

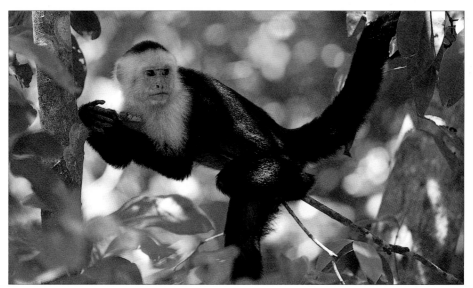

WHEN I SPOTTED a troop of white-faced capuchin monkeys moving through trees, I followed them as best I could and was rewarded by older individuals pausing to rest while the youngsters played. This picture shows typical dappled lighting of sun and shadow; fortunately the white face is in shadow and the sunlit leaves behind help to define the outline of the dark body. I like the nonchalant pose, and the lack of eye contact with the camera is a good thing in this instance because it proves that the animal (who was clearly aware of my presence) was completely relaxed. The highlights in both eyes are entirely natural reflections from bright spots in the forest.

> **White–faced capuchin monkey**
> ***(Cebus capucinus)***
> Parque Nacional Manuel Antonio,
> Costa Rica, April
> Nikon F4, 300mm lens, Kodachrome 200

At Altitude

LIFE IN MOUNTAINS is exhilarating; the air is pollution-free and the constantly changing weather presents many challenges for the photographer. Plants and animals are specially adapted to the rigours of life at high elevations. Before the ground is blanketed by thick snow, many animals hibernate and plants become dormant, but once the snow melts, the alpine meadows are ablaze with colour and animals forage busily. Huge snowdrifts around the summit of the mountain road in Glacier National Park caused me to abandon the idea of stalking mountain goats. However, I was rewarded by finding this ground squirrel emerging from its burrow deep in the snow bank to bask in the sun. No sooner had I set up my camera than a group of visitors noisily tramped by, causing the squirrel to bolt down its hole. This happened repeatedly, but luckily the ground squirrel

– determined to make the most of the warm day – soon re-emerged. The snow conveys the montane habitat, but I had to spot-meter off the squirrel's fur.

Columbian ground squirrel
(Spermophilus columbianus)
Glacier National Park, Montana, USA, June
Nikon F4, 200–400mm lens, Kodachrome 200

POINTS TO WATCH

● *At altitude, the increased ultra-violet radiation will give mountain views a blue cast unless a skylight filter is used.*
● *A conventional tripod is difficult to carry when climbing; whereas a small model such as a Baby Benbo can be strapped to a rucksack.*
● *Mountain weather can change rapidly, so be prepared by carrying a compass as well as water and food.*

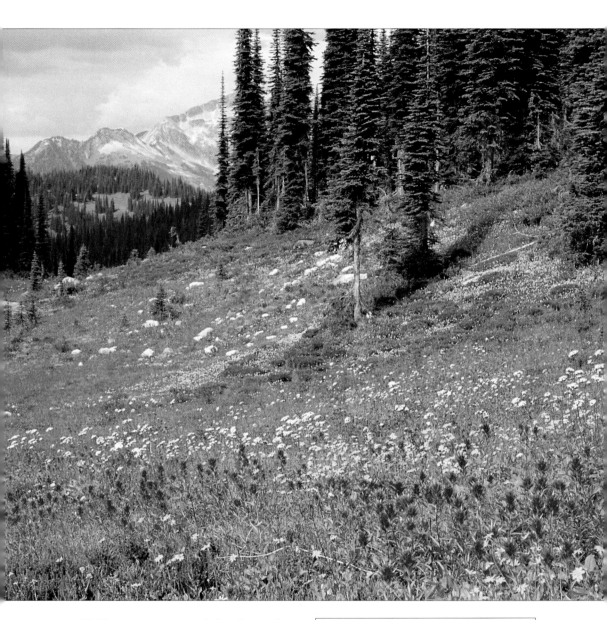

UNLIKE some mountain locations, where
I have had to trek for several days to
reach my goal, the one above was easily
accessible. We simply took a coach ride
up to 1,900 metres (6,300 feet) and walked
along the paths meandering through the
meadows over which visitors are no
longer allowed to wander. Quite by chance,
we discovered that it was the peak time
for the ephemeral colourful display.

Human trampling can do untold dam-
age to delicate plants which may take many
years to recover. I selected this viewpoint
with the flowers providing foreground
colour in a horizontal plane, the trees adding
vertical elements and the snow-covered
peaks conveying the alpine setting.

**Sub-alpine meadow with paintbrush
(*Castilleja miniata*), giant ragwort (*Arnica* sp.)
and valerian (*Valeriana sitchensis*)**
Mount Revelstoke National Park,
British Columbia, Canada, August
Nikon F4, 35mm lens, Ektachrome 100 Plus

POINTS TO WATCH

● *Spring comes later with increasing altitude;
if plants have finished flowering at one level,
try climbing higher to find late-blooming plants.*
● *It can be very windy above the tree-line,
but low-growing alpines that hug the ground
can be photographed in almost any weather.*
● *Carry a pair of binoculars to search for
distant plants across water or high on ledges.*

Seasonal Aspects

The seasons bring dramatic visual changes to the landscape.
These range from the fresh greens of spring, through the glowing golds
and fiery reds of autumn to the white blanket of winter snow.
The seasons also set the pace for the rhythms of life with breeding and
migration times inextricably linked to them.

EACH SEASON brings with it great variation not only in the appearance of wilderness areas, but also in the range of wildlife and plant subjects available for photography. As the daylight hours increase in temperate regions, there is more time for animals to feed and also for photographers to record their activities; in the Arctic, photography is possible for 24 hours a day during the summer. Even though the sequential rhythms of the seasons are predictable, the precise time when winter ends and spring begins is weather dependent, therefore it may vary considerably from one year to the next. The onset of spring also varies with latitude and altitude, and comes later the further north you go in the northern hemisphere (or south in the southern hemisphere) and the higher you climb. Therefore, if I have been working abroad and a particular kind of catkin, for example, is past its best on my return, I simply drive further north to find a good specimen for photography. For many years I have kept a perpetual nature calendar which records the date when I first noticed a specific tree leafing out, a plant coming into flower, or an insect on the wing in spring. Since this information has now been transferred to a computer database, I can readily access a given subject, location or month of the year when planning a trip, to find out what is likely to be available. When a deciduous tree changes colour in autumn, the hues that develop are distinctive to each species. I was, therefore, delighted to discover this multi-coloured tapestry of green, yellow and bronze-leaved beech branches. Once found, a zoom lens gave me a perfect crop of the coloured sectors without any ground or sky appearing in the picture.

> **Beech *(Fagus sylvatica)* trees in autumn**
> Burnham Beeches, Buckinghamshire, UK,
> October
> Nikon F4, 80–200mm lens, Fuji Velvia (ISO 50)

POINT TO WATCH

● *Do not delay in taking autumnal colours because, once the leaves turn colour, they will fall all too easily whenever a wind blows.*

76

Spring Life

THE ONSET OF SPRING heralds warmer and longer days which stimulate new life as buds burst and young birds hatch. Unlike the helpless, naked chicks of many garden birds, swan cygnets emerge covered in fluffy down and can walk shortly after hatching.

For once, I was glad it was a cold day because all the cygnets remained huddled beneath their mother's wings for warmth. I prefocused with my long zoom lens so that I was ready for the magical moment when one of the cygnets suddenly popped out on its mother's back.

Mute swan *(Cygnus olor)* chick
Abbotsbury Swannery, Dorset, UK, May
Nikon F4, 200–400mm lens,
Kodachrome 200 rated at ISO 500

POINTS TO WATCH

● *Mute swans take 36 days to incubate their eggs, so this time can be spent locating accessible vantage points overlooking nests, ready for the moment the cygnets hatch out.*
● *When older cygnets take to the water they can be photographed swimming in line, following behind one of their parents.*

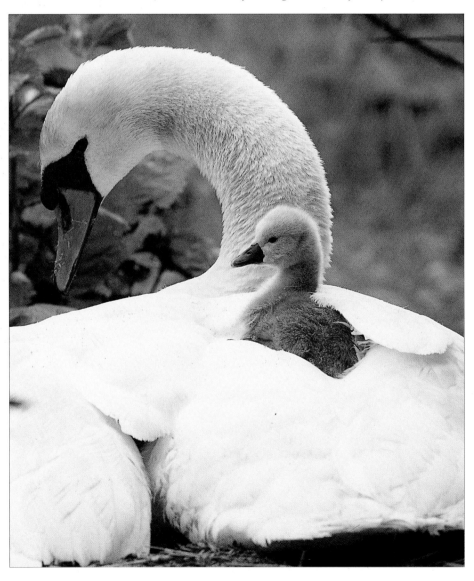

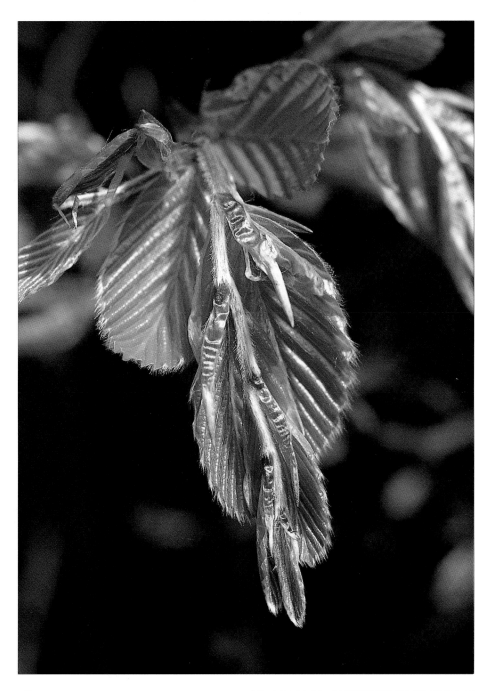

SPRING AND AUTUMN are the best seasons for photographing most deciduous trees; beech is no exception. The elongated pointed beech buds burst to reveal the fresh green leaves reminiscent of a permanently pleated skirt. I spent some time searching for a low-level branch so that the frame would be filled using the sole macro lens I then possessed. I relish the time deciduous trees leaf out, because the subtle, but ephemeral, hues revert all too soon to the coarser greens of midsummer.

Beech *(Fagus sylvatica)* leaves
Hampshire, UK, May
Nikkormat FTN, 55mm macro lens,
Kodachrome II (ISO 25)

POINTS TO WATCH

● *Search for a branch tip that can be isolated against a background in shadow or a blue sky.*
● *If the best branch is high up, use a long-focus lens, if necessary with a small extension tube, to get a good-sized image.*

Summer Glory

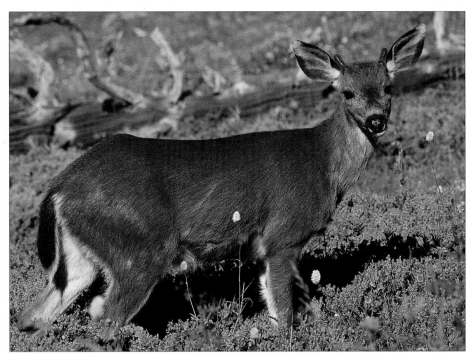

I N THEORY, summer in temperate latitudes, with extended daylight hours and warm weather, should be the best time for outdoor photography. But for most of the day, with the sun high in the sky, the light can be very harsh. The picture above was taken early in the morning as we were driving up a high altitude road. I had a 80–200mm lens on the camera, but when the black-tailed deer came over to investigate us, I had to change to a 50mm lens, so as not to crop the animal pausing among cream spikes of beargrass.

Black-tailed deer
(Odocoileus hemionus)
Olympic National Park, Washington, USA, July
Nikon F4, 50mm lens, Kodachrome 200

M ANY BUTTERFLIES are on the wing in the summer, although modern agricultural practices have reduced the sites of some food plants and hence numbers of butterflies. When they alight on a flower, these insects often close their wings; then, provided the film plane is parallel to the wings, a minimal depth of field is required. For this backlit study of a marbled white, I made sure that the insect was sharp, yet the background grasses were thrown out of focus by using an aperture of f8.

Marbled white butterfly *(Melanargia galathea)*
Noar Hill, Hampshire, UK, July
Nikkormat FTN, 105mm macro lens,
Kodachrome-X (ISO 64)

Grasses are invariably passed over in preference to colourful flowers; yet, in the right light, they offer challenging scope for novel plant pictures – whether a wide shot of wind rippling across prairies or close-up studies. I take grasses when the natural lighting causes them to stand out from their surroundings.

Such was the case with the grasses above, backlit against a background in shadow. Because they were blowing in the wind, I had to use a fast shutter speed (1/250 second) to freeze them.

Backlit grasses
Great Smoky Mountains National Park,
North Carolina, USA, September
Nikon F4, 85mm lens, Kodachrome 200

POINTS TO WATCH

● *Use a low camera angle to make tall grasses stand out against the sky, or look for a light and shadow contrast.*

● *In overcast weather, create backlighting by using a flash supported on a small tripod or on a pole that can be pushed into the ground.*

Autumn Furnace

EVERY NATURE PHOTOGRAPHER knows the importance of timing. It was dark when I drove north to the Peak District in search of autumn colours. The omens looked bad at dawn when I discovered that all the roadside trees were reduced to leafless skeletons. I scanned a map to find a sheltered location and was rewarded with an evocative muted autumn landscape, reminiscent of a painting, across the far side of a reservoir. I used my 200–400mm zoom on the longest setting to include the larches, still clothed in golden needles, behind a stand of evergreen conifers with leafless mountain ash laden with red fruits filling the foreground. The timing was perfect; if the leaves had remained on the trees, they would have hidden the colourful fruits.

Here is an example of a subtle autumn landscape that does not leap out of the page. I find it grows on me each time I look at it. The diagonal line that separates the golden larches from the sombre green conifers is repeated by the more irregular line of the mountain ash trees below.

My initial instinct was to use a horizontal composition (cropped slightly to fit the space here); but knowing that picture editors often require upright shots, I also tried taking the scene as a vertical format. Instead of blending in harmoniously, however, I found that the juxtaposition of the colour blocks created a jarring effect.

**Larches (*Larix decidua*) with
fruiting mountain ash (*Sorbus aucuparia*)**
Ladybower Reservoir, Peak District, UK,
October
Nikon F4, 200–400mm lens, Fuji Velvia (ISO 50)

POINTS TO WATCH

● *Once deciduous trees turn in autumn, be ready to record their colour. Anticipate strong winds by checking out weather forecasts.*
● *Be prepared to be adaptable; don't relegate your long lenses solely to taking wild birds and mammals. This arboreal landscape would not have worked so well had I used a shorter lens; the blocks of colour would have lost their impact.*

Shades of Autumn

AUTUMN IS A TIME OF YEAR when greens no longer dominate the natural scene. Instead, a kaleidoscope of yellows, oranges, reds and browns develops as leaves on deciduous trees lose their chlorophyll and fungi appear – sometimes overnight.

Since the interior of coniferous forests is typically dark and dingy, the tiers of orange and yellow brackets appeared to glow from the brown trunk. The still air enabled me to use a half-second exposure with a small aperture for maximum depth of field.

Chicken-of-the-woods (*Laetiporus sulphureus*)
Hanson Island, Robson Bight, Canada, August
Nikon F4, 50mm lens, Kodachrome 25

POINTS TO WATCH

● *Many fungi are short-lived, so they should be taken immediately they have been located.*
● *A reflector or a fill-flash is useful for filling in shadows on close-ups in dark forests.*

ELK ARE WIDESPREAD in the Yellowstone National Park, but such a fine stag carrying twelve points on his rack of antlers does not often conveniently feed adjacent to the road.

Although these animals are conditioned to visitors and will tolerate a fairly close approach, I prefer the perspective gained with a long lens which also has the advantage of allowing me to change the background simply by moving a few paces to one side or the other.

Elk or wapiti (*Cervus canadensis*)
Yellowstone National Park, Wyoming, USA,
September
Nikon F4, 200–400mm lens, Kodachrome 200

POINT TO WATCH

● *If any wild animal shows signs of distress by your presence, either by ceasing to feed or by laying back its ears, be sure to back away.*

HAVING STOPPED to take a closer look at a roadside sugar maple tree, I was drawn into the forest and immediately attracted by the patchwork of fallen leaves and pine needles on the forest floor. I was fortunate the leaves had fallen recently because, once shed, they quickly shrivel and are eaten by the myriad inhabitants of the leaf litter. To ensure the entire frame was sharply in focus, I positioned the camera back (and therefore the film) parallel to the ground using the versatile Benbo tripod.

Fallen maple leaves amongst pine needles
Vermont, USA, October
Hasselblad 500 C/M, 80mm lens with close-up lens, Ektachrome 64

POINTS TO WATCH

● *When backlit, red or yellow leaves appear to glow. When side lit against a blue sky, enhance the contrast with a polarizing filter.*
● *Autumnal leaves and berries introduce vibrant colour to otherwise drab scenes.*

Winter Wonderland

FROST OR SNOW can transform a landscape into a winter wonderland. Snow provides such a good contrast to grazing mammals that they stand out – even when silhouetted from a distance. When the sun broke through, it made me look anew at a previously drab scene of foraging bison. Because I was reluctant to crop the line of bison, I opted for a wide-angle lens.

The backlighting gives depth by casting diagonal shadows from trees on the snow-clad slopes. Had the sky been colourless, I would have used a grey graduated filter.

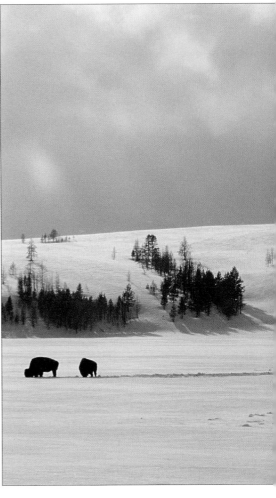

Bison *(Bison bison)*
Yellowstone National Park,
Wyoming, USA, February
Nikon F4, 35–70mm lens, Ektachrome 100 Plus

POINT TO WATCH

● *Ensure tripod legs are pushed down into snow so that they are rigid. With powdery snow, use cardboard as makeshift snowshoes.*

SPECTACULAR FROSTS develop when fog combines with freezing conditions. A prevailing wind caused inch-thick frost to build up on one side of the ivy leaves and fruits (left). An overcast day created the perfect light for this ephemeral frost formation which persisted for two days.

Heavy hoar frost on ivy *(Hedera helix)* **leaves**
Crondall, Surrey, December
Nikon F4, 80–200mm lens, Fuji Velvia (ISO 50)

DEEP SNOW blankets the ground, masking eyesores to create curvaceous lines as seen with these boulders. Their shape and texture are reminiscent of outsized silkworm cocoons. To get this shot (opposite), I waded through waist-high snow and waited for sun to light the boulder tops.

Snow-covered boulders in stream
Wyoming, USA, February
Nikon F4, 200mm lens, Ektachrome 100 Plus

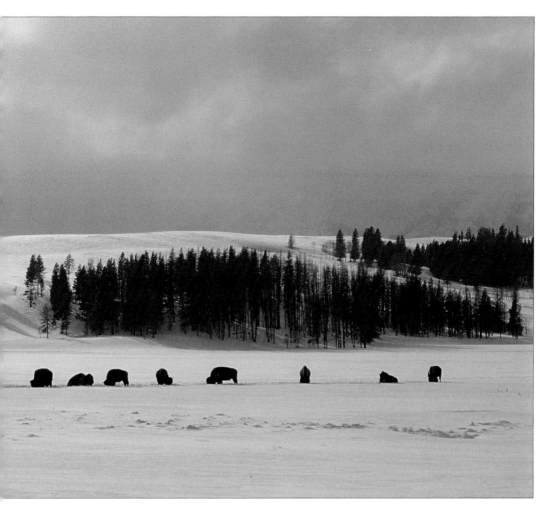

Winter Wildlife

COMPARED TO SPRING, winter is a time when the range of animals for photography is much reduced, but those that do not hibernate or migrate to warmer climes none the less have to emerge to feed. Knowing their preferred food or favourite haunts is a crucial factor in achieving unusual pictures. Pertinent tips for cold-weather photography are mentioned on pages 39 and 70.

Arctic foxes can often be found in the same vicinity as polar bears because they frequently scavenge on left-overs. Normally they keep a safe distance between themselves and the large carnivores otherwise, as I once witnessed, they end up being an hors d'oeuvre for the bear. These foxes are extremely tolerant of the cold and only begin to shiver at –70°C! While I was working at Cape Churchill taking polar bears, I saw arctic foxes on most days and I particularly liked the way this one was trotting among the uplifted sea ice, rimlit by a weak sun. I took the picture from inside a tundra buggy – a purpose-built vehicle for moving over the icy tundra.

> **Arctic fox *(Alopex lagopus)***
> Cape Churchill, Canada, November
> Nikon F3 with cold-weather battery pack,
> 300mm lens, Kodachrome 200

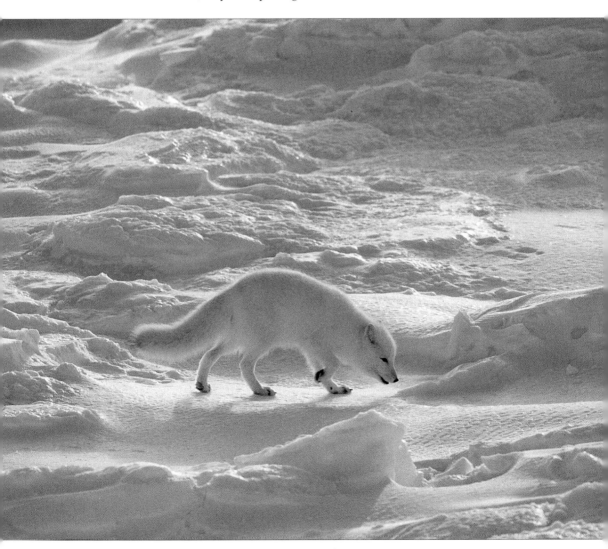

WINTER FOGS are a feature of the low-lying Lower Klamath Basin and, when the sky is clear and the temperature plummets overnight, spectacular frosts form. Trees are sparse in this wetland site, so I noted cottonwoods lining a dyke. Next morning I arrived at first light before warmth from the sun's rays began to destroy the frost fantasy. It was a bonus to find this raptor in a frost-spangled tree. Using the car as a hide, I took the picture with the camera supported on a window clamp.

Raptor in frost-covered cottonwood
Lower Klamath NWR,
California, USA, February
Nikon F4, 200–400mm lens, Kodachrome 200

Portraying the
Environment

Animals and plants are adapted to live within specific habitats,
the characteristics of which are determined by their geology,
topography, temperature extremes and amount of rainfall.
This chapter outlines the special problems associated with photographing
habitats as diverse as wetlands, deserts, the sea and African savanna.

SEEKING OUT and taking striking pic-tures which clearly depict plants and animals within their environment gives me a great deal of satisfaction. Contrary to popular belief, this ap-proach to photographing the natural world is by no means an easy option compared to taking a frame-filling por-trait. For one thing, the available light cannot be modified – except by using a filter – therefore the entire frame has to be lit in a way that does justice to both the habitat and the subject. This does not mean that all habitats have to be lit in the same way; for instance, it is possible to take trees and animals back-lit – even silhouetted – yet still be able to convey the nuance of the habitat. I often find that decisions about where to position the subject in the frame and how to crop the picture are inextricably linked to the way in which the habitat is lit. Situations where animals are mov-ing through a habitat are arguably the most problematical of all. With static plants or stationary animals, you can spend time carefully considering the

composition and how the subject relates to its environment. Not so with active animals, when rapid decisions have to be made about how to frame the picture. After I had spent some time taking small groups of seabirds nesting on an island off Ireland, I noticed a graphic – almost monochromatic – picture staring me in the face. An overcast day gave perfect, even lighting for this shot depicting the way in which guillemots utilize every available horizontal and inclined ledge. These birds were taken from a clifftop looking across an inlet from one rocky headland to another, but when birds nest on a sheer cliff wall, the best viewpoint is from a boat at sea level.

> **Guillemots (*Uria aalge*)**
> Great Saltee Island, Ireland, May
> Nikkormat FTN, 135mm lens,
> Kodachrome-X (ISO 64)

POINT TO WATCH

● *I adopt two approaches for getting my eco-pictures. Firstly, I research beforehand what flora and fauna typify the habitat; secondly, I keep my eyes open for an attractive composition.*

PORTRAYING THE ENVIRONMENT

Reading the Landscape

EVERY LANDSCAPE presents a range of clues as to its age and the dominant natural forces that moulded it. Old landscapes tend to be smooth and rounded, while young landscapes are rough and jagged. Where ice has been the major moulding force, valleys are U-shaped, and lines of rocky debris (moraines) dumped by retreating glaciers may dam valleys. Recent events, however, may have scarred what you now see; earthquakes can trigger rock slides, and cause the land either to rise (maybe leaving remains of marine animals stranded high and dry) or to fall so that the sea then rises. Unvegetated landscapes built up from sedimentary deposits are constantly sculpted by wind and rain; where frosts occur, hard rocks are shattered by repeated freezing and thawing. The snow-covered hills below were a lucky chance encounter and the picture I took still remains one of my favourites. It depicts a landscape moulded by wind, rain and frost as well as showing the effect of aspect. Warmth from the sun had melted the snow on the south-facing slopes, but not on the opposite faces in shadow. This contrast makes for a more powerful composition than if the hills had been uniformly white.

Snow-covered hills
Painted Desert, Arizona, USA, February
Nikon F3, 200mm lens, Kodachrome 25

POINT TO WATCH

● *A fine dusting of snow adds contrast – without obscuring features – to geological land forms.*

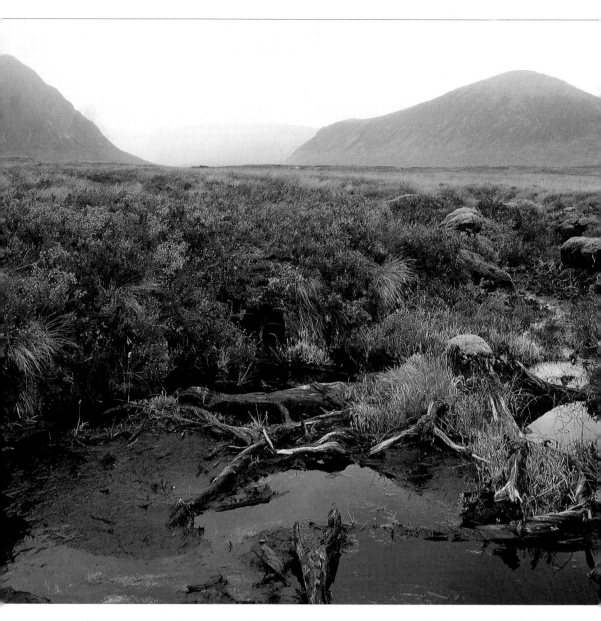

THE PICTURE ABOVE tells several stories. In the foreground, the bog pine exposed in eroded peat reveals a change in climate and habitat; when the pine was alive the ground would have been drier. As the valley became wetter, the forests gave way to a peat bog which has preserved many pine trees from the old forest. The U-shaped profile of the valley behind confirms that this area was once glaciated.

To bring all these elements together, I chose a wide-angle lens and a low viewpoint. A grey graduated filter would have enhanced the pale sky, but it is difficult to use in a subtle way when high hills rise up on either side of a valley, because if the base of the colour strip is placed above the mountains, the sky above the valley remains unfiltered. Conversely, when the coloured strip is lined up with the horizon, the hills become darker. To emphasise the foreground, I cropped the finished photograph just above the top of the hills.

Bog pine in eroded peat
Rannoch Moor, Glencoe, Scotland, September
Hasselblad 500 C/M, 60mm lens,
Ektachrome 64

POINTS TO WATCH

● *Low-angled winter light is better at revealing slight changes in elevation in a flat landscape than an overhead summer sun.*
● *Bogs can be treacherous, so it is sensible not to venture out into a boggy area without a companion.*

Floral Carpets

IT IS DIFFICULT to reproduce the colour, as we see it, of many blue flowers – notably bluebells – on colour transparency film. The reason is that the blue flowers reflect some far red and infra-red wavelengths which are invisible to the human eye but recorded on some colour film emulsions. I knew that the blue of this glorious carpet would appear more authentic if lit by indirect light, so I waited until a cloud passed over the sun. The oak branches were included within the framing to add colour contrast.

Bluebells (Hyacinthoides non-scripta)
Conservation Area, Royal Botanic Gardens,
Kew, Surrey, UK, May
Hasselblad 500 C/M, 250mm lens,
Ektachrome 100 Plus

POINT TO WATCH

● *When using transparency film to take close-ups of blue flowers, use a 20 BB colour compensating filter to enhance the blue. It will, however, disturb the balance of any green leaves and stems.*

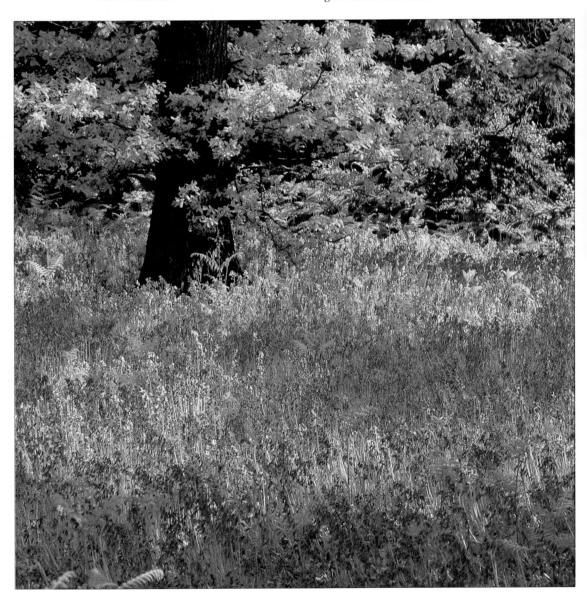

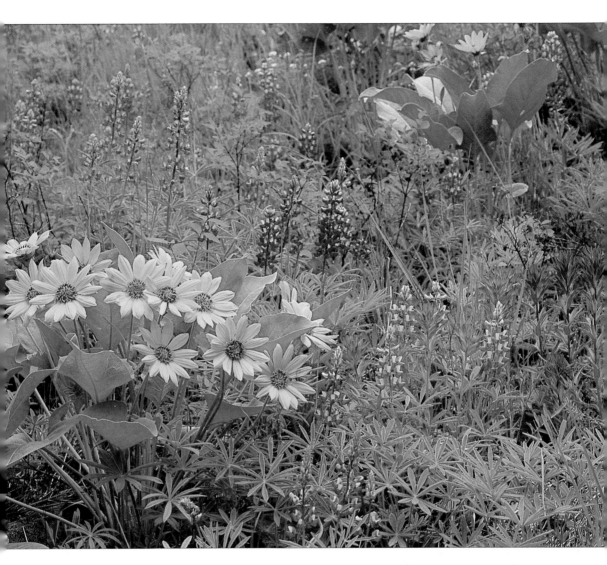

WHILE INDIVIDUAL WILD FLOWERS can make striking close-up studies, sheets of flowers blooming on alpine meadows, in grasslands or carpeting deciduous woods before the trees leaf out, are a glorious ephemeral sight, which need to be captured before rain falls and causes spotting to the petals. Floriferous alpine meadows may present opportunities for using a wide-angle lens to frame foreground colour with a distant snow-covered peak behind.

It was a dull day when I found the multicoloured group of flowers growing beneath pines on the Bitteroot Mountains and they brought a welcome warmth to the otherwise rather drab scene. A medium zoom lens gave me the cropping I wanted with a small cluster of yellow flowers echoing the main group; comparison between Fuji Velvia and Kodachrome 25

showed that Velvia provided better colour saturation on an overcast day.

Wild flowers, arrowleaf balsamroot (Balsamorhiza sagittata), paintbrush (Castilleja sp.) and lupins (Lupinus sp.)
Bitteroot Mountains, Montana, USA, June
Nikon F4, 80–200mm lens, Fuji Velvia (ISO 50)

POINTS TO WATCH

● *Use commonplace flowers growing in profusion as a challenge to produce many different studies of a single subject. Try varying the focal length of the lens as well as the camera viewpoint and the lighting.*

● *In an open situation, use a panoramic camera (even throwaway models give good results) to gain a wider sweep of colour.*

Forest Interiors

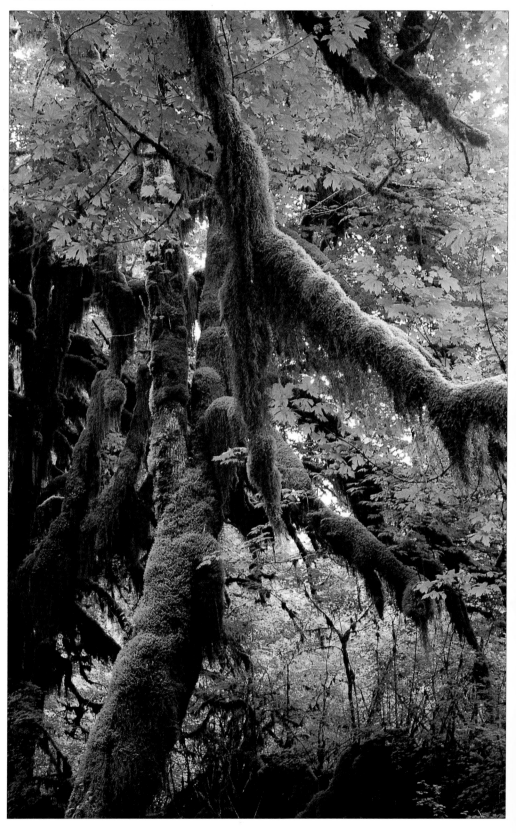

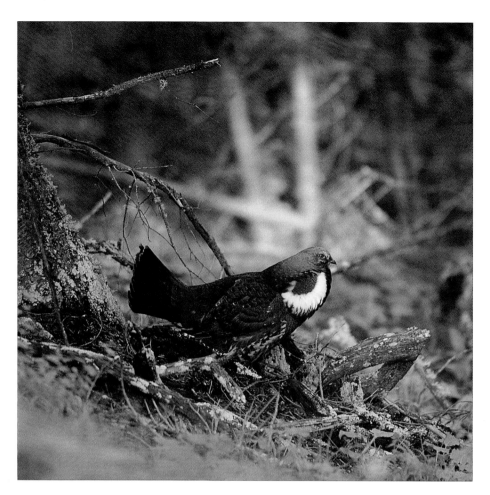

FOREST INTERIORS can be one of the most rewarding of habitats to work in because as well as trees, their trunks, leaves, flowers and fruits, there is a galaxy of exciting close-up subjects such as mosses, ferns, fungi and flowers. This rich potential is, unfortunately, tempered by photographic problems. If the sky is overcast and the overhead canopy thick, the ambient light can be very low, necessitating the use of long exposures if you are using slow-speed film. On a sunny day, shafts of light beam down on to the forest floor producing contrasty, dappled lighting which colour transparency film does not have the latitude to record accurately. I was, therefore, relieved to see a cloudy sky on the morning I had allocated for taking mosses festooning the trunks and branches. I rejected a 24mm lens in favour of a 35mm, which cropped out the white sky and left an overall green scene.

ON OUR WAY to an alpine meadow for bighorn rams, we spotted a male blue grouse beside the track. The bird moved off into a Douglas fir forest, but fortunately it began to call in a clearing so I was able to get a good view from the road using a long lens. The glint in the dark eye was a bonus, but I should have preferred the pale-toned trunks behind the bird to have been in shadow. Note the neck sac which becomes inflated as he produces a curious drumming sound to attract females. The grouse continued to call for a full hour.

Blue grouse (*Dendragapus obscurus*)
Bitteroot Mountains, Montana, USA, June
Nikon F4, 200–400mm lens, Kodachrome 200

POINTS TO WATCH

● *Avoid getting hot spots from a white sky at the top of the frame; a grey graduated filter will reduce the contrast, but it will give an unnatural colour strip across the tree tops.*
● *If a forest plant is lit in a striking way, take your shot immediately because the sunbeam angles piercing the canopy change constantly.*

Epiphytic mosses on big leaf maple
(*Acer macrophyllum*)
Olympic National Park, Washington, USA, July
Nikon F4, 35mm lens, Kodachrome 25

At Sea

BEING IN A BOAT at sea involves a completely different way of working from on land. Long hours are spent scanning the surface for signs of life appearing from the depths; when a dolphin or whale does surface, the action is over within seconds. A blue whale is so huge that only part of the body appears above the water; even so, if all the visible part is included in the frame, there is inevitably an extensive area of both sea and sky, which does not lead to an exciting composition. Therefore, when an animal surfaced beside our boat, I decided to crop in tight on the head.

Blue whale *(Balaenoptera musculus)* **blowing**
Sea of Cortez, Baja California, Mexico, March
Nikon F3, 200mm lens, Kodachrome 200

POINTS TO WATCH

● *Since both the boat and the whale are moving, the slowest shutter speed that can be used without risk of subject blur will be 1/250 – maybe 1/500 – second. Depending on the angle at which you view the sea surface, the reflected light reading can vary by 2½ – 3 stops. Therefore, set the camera to shutter priority mode to take care of any variation in light levels.*
● *Use a motor drive to capture a photo sequence as a whale surfaces, blows or dives.*

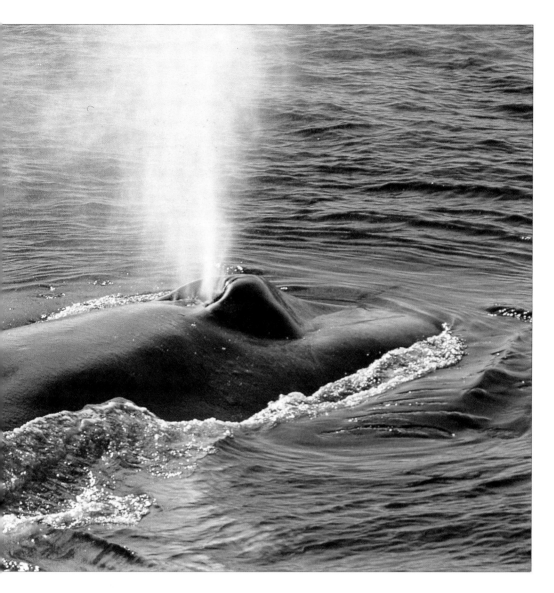

OTHER PICTURE POSSIBILITIES at sea in coastal waters include seabirds following in the wake of a boat, abstract patterns of reflections on the water surface (see page 60), jellyfish and floating objects such as seaweed and driftwood. Extensive growths of large brown seaweeds form kelp forests in coastal temperate seas. When storms rage, they wrench the hold-fasts of giant kelp plants from rocks so that they break free and float to the surface. From a distance, giant kelps (opposite) resemble outsized light bulbs bobbing on the sea because the bulbous float at the top of the stalk is the most conspicuous part of the seaweed. When viewed against the light the kelp plants made an intriguing design. I decided not to use a polarizing filter because I liked the contrast between the silver water and the brown seaweeds.

Giant kelp
Robson Bight, British Columbia, Canada, July
Nikon F4, 200mm lens, Kodachrome 200

POINTS TO WATCH

● *Sea water is highly corrosive, so protect all lenses from spray with a skylight filter.*
● *It is worth searching strandlines on the shore for pieces of driftwood with goose barnacles attached.*
● *Strands of brown seaweeds which become exposed at low tides can be photographed either from the shore or from a boat with a shallow hull which will permit a close approach.*

Dry Deserts

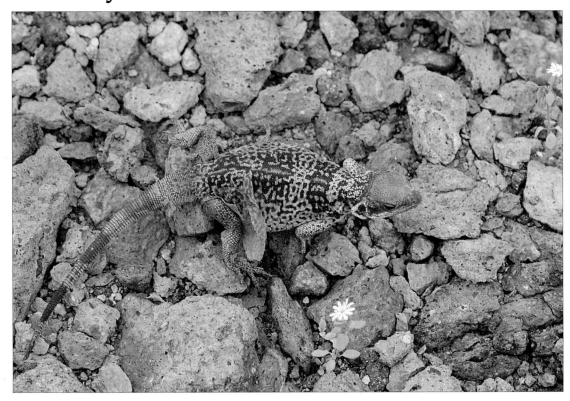

DESERT FLORA AND FAUNA are adapted to withstand long periods of drought, but when rains come, they trigger the germination of annuals which can transform an unspectacular area into a breathtakingly colourful scene. Animals such as reptiles, that live and move over the ground, tend to be well camouflaged to confuse their predators. I would have missed the lizard above if it had not scuttled over the volcanic rocks. It was a bonus to find it mid-moult with the old skin peeling off the body. Because it was overcast, and I wanted to stop down my macro lens, I used a monopod to steady the camera.

Chuckwalla lizard moulting
Baja California, Mexico, March
Nikon F4, 105mm macro lens,
Ektachrome 100 Plus

POINT TO WATCH

● *Be prepared for searing daytime temperatures in deserts; carry plenty of water and keep films cool in the centre of a gadget bag.*

FOR MOST OF THE DAY, harsh desert light is not conducive to photography, so I spend this time driving around in search of possible plants and viewpoints. Cacti can produce showy flowers, but for most of the year it is their shape and form which attract the eye. I spotted the teddy bear cholla around noon and made a mental note to return late in the day when the low-angled sun would rimlight the spines to give a golden glow to the plants.

Bigelow's or teddy bear cholla
(Opuntia bigelovii)
Joshua National Monument,
California, USA, February
Nikon F3, 50mm lens, Kodachrome 25

POINTS TO WATCH

● *Be careful not to back up against these cacti which have hooked spines that are both painful and difficult to extract.*
● *Beware of flash floods; never park a vehicle in a wash area where water is known to suddenly race.*

Still Water

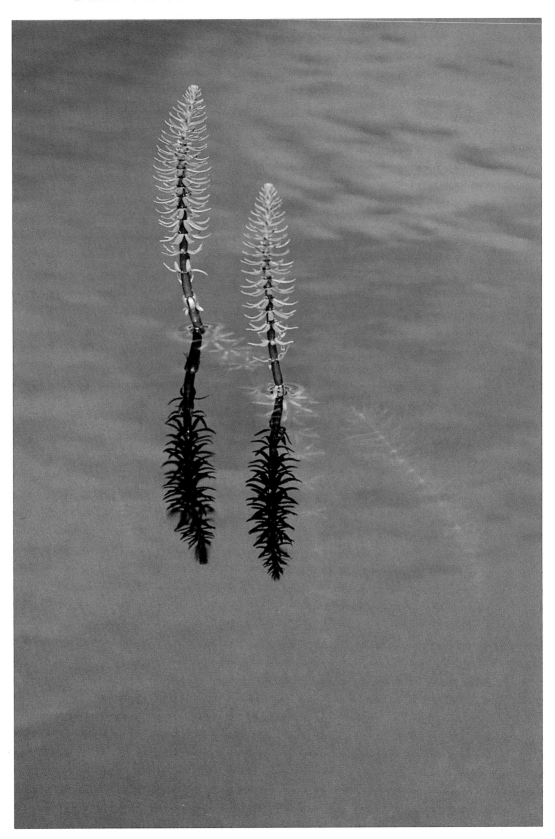

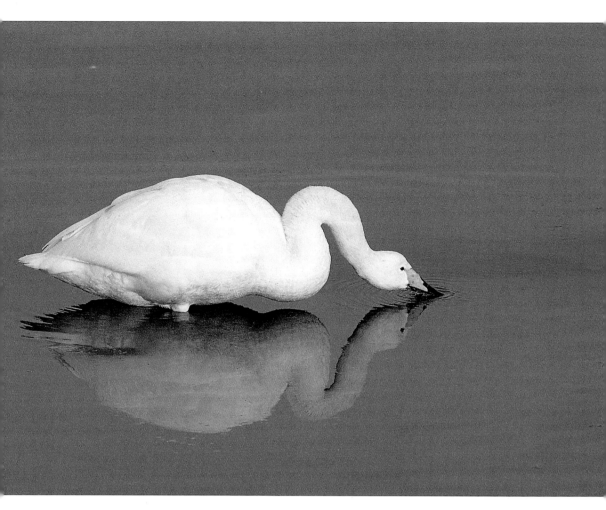

CHAMELEON-LIKE, still water takes on the colour of its surroundings – whether it be a blue sky, green plants or their coloured flowers. Vegetation in Greenland lakes tends to be sparse, which can be an advantage when searching for simple shapes and their reflections.

This picture works because the spikes are in one plane and their silhouetted reflections are not distorted by surface ripples. I metered for the green stems by taking a reading from a dense group of adjacent marestails.

AS A SWAN dips its bill into the water, ripples radiate out from the point of contact – a simple enough study, but the opportunities to isolate a solitary swan without portions of other birds encroaching the frame were limited. The lack of plants gives no hint of the type of wetland. In fact, it was the same stretch of coastline where I took the mass of swans at dawn (p.38), but by mid-afternoon the air temperature had risen to just below freezing.

Marestails *(Hippuris vulgaris)*
Greenland, July
Nikon F4, 200mm lens, Kodachrome 200

Whooper swan *(Cygnus cygnus)*
Hokkaido, Japan, January
Nikon F4, 80–200mm lens,
Kodachrome 200

POINTS TO WATCH

● *When photographing plants in white or dark water, take care with metering. Either use an incident-light meter or look for an average-toned object near by.*
● *Add colour to water by including reflections of waterside flowers or autumnal foliage.*

POINTS TO WATCH

● *Look for perfect reflections at first and last light when the water surface is often calm.*
● *Long-legged waders make striking shapes when they appear reflected in calm water.*
● *Avoid shooting a wetland against the light with a dark backdrop when insects are swarming since they will appear as bright specks.*

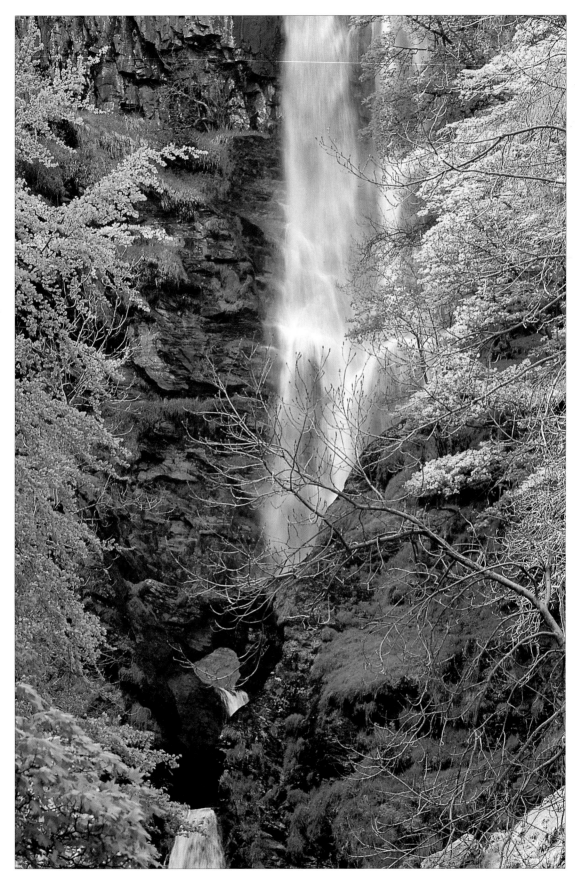

Moving Water

THERE ARE TWO APPROACHES to photo-graphing flowing water. Whether it be a high waterfall, a series of cascades or a rippling stream, water can either be frozen with a fast shutter speed or blurred with a slow one (see page 26). I prefer the latter approach, which works best when there is a limited flow of water and you are using a slow-speed film. The waterfall on the left is so narrow that it does not make a picture on its own, so I timed my visit to coincide with the beech trees leafing out to give additional interest and colour.

APART FROM FISH, only a few animals are adapted to swim against the fast-flowing current in a river. The merganser is a bird that frequents torrents and this picture shows one moving against surging water at the base of a waterfall. I focused my camera on the merganser, keeping the same exposure I had used earlier when I metered from the flank of a bear, because the above-average tone of the white water would have resulted in an underexposed picture. I love the way the water is swirling around the bird, conveying its vulnerability against the power of the moving water.

Pistyll Rhaeder waterfall
Pistyll Rhaeder, Wales, June
Hasselblad 500 C/M, 150mm lens,
Ektachrome 64

POINT TO WATCH

● *Do not meter a waterfall directly because the white water will give a false high reading which will result in the picture being underexposed. Either use a hand-held meter to take an incident reading or meter through the camera off neutral-toned rocks.*

Merganser (*Mergus merganser*) swimming
Brooks Falls, Katmai National Park, Alaska, USA, July
Nikon F4, 500mm lens, Kodachrome 200

POINT TO WATCH

● *When working with two mobile elements – racing water and a swimming bird – slacken the ball and socket head on the tripod, gently panning it to keep the bird in the frame.*

Savanna Grassland

THERE IS NOTHING anywhere in the world to compare with the sheer spectacle of the African savanna teeming with life that is constantly on the move. Even though I have visited Africa on many occasions, I still get a great thrill seeing game in the wild and I never become blasé because every day is different. Take, for example, the elephant herd opposite. I had already spent several hours getting frame-filling shots of individual and small groups feeding and wallowing in a swampy area. But I also wanted to illustrate the size of the herds which can be seen in Amboseli as well as the variation and size of the individuals. We anticipated where a herd would pass and sat waiting for them to approach us. Note the dust cloud stirred up by the marching elephants.

African elephants *(Loxodonta africana)*
Amboseli National Park, Kenya, April
Nikon F4, 80–200mm lens, Kodachrome 200

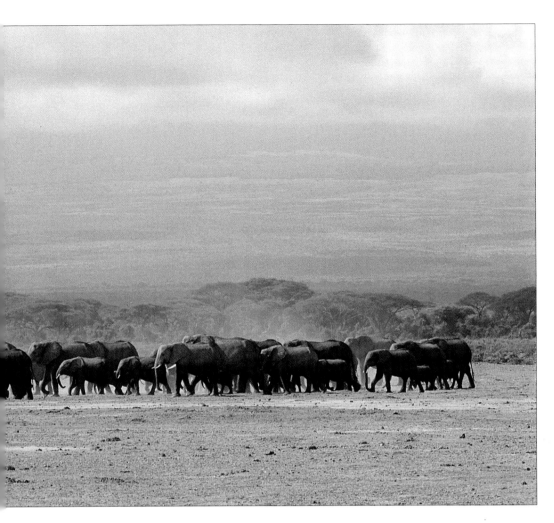

M OST PEOPLE visit the game parks during the dry season because dirt roads become quagmires when it rains and even four-wheel-drive vehicles can get bogged down. However, drought means that dust gets everywhere inside an open vehicle. If a dusty layer builds up on the front lens element, this will ruin the definition, while even a single grain of grit inside the camera can cause scratches on the film emulsion. Before changing a film, I therefore wipe the outside of the camera with a damp cloth. Also I periodically check the front of the lenses for dust and each night I use a blower brush to clean lenses and cameras.

When not actively hunting, lions seek out a shady patch in which to rest during the heat of the day. We found the lioness (opposite) early in the morning peering through a leafy frame. After we stopped, she made no attempt to move, so I had time to compose this shot with direct eye contact, using a window clamp to support the camera. With a heavy lens, I hold one hand on top to help dampen the vibration.

Lioness (Panthera leo)
Masai Mara, Kenya, Africa, April
Nikon F4, 200–400mm lens, Kodachrome 200

POINTS TO WATCH

- *Never change films when following behind another vehicle on a dusty road.*
- *Always heed park rules; never alight from a vehicle except in a safe area.*
- *Refrain from making sudden noises or talking loudly, although a slight sound – such as a shutter being released – can make an animal appear more alert.*
- *Avoid wearing photographic vests with Velcro fastenings, since the noise they make when opened can disturb timid animals.*
- *A tripod is impractical if sharing a minibus. Use a window clamp, a bean bag or a Tri-bag to cradle a camera with a long lens on the window frame. Alternatively use a shoulder pod or a monopod inside the vehicle.*
- *Refrain from photographing in the middle of the day when the sun is high, because the light is harsh and the animals are inactive.*

On Safari

WHEN WE SET OUT at first light from our Kenyan lodge, our main objective was to find cheetahs. Our task was made easier by the fresh green grass, triggered by the rains, providing a good colour contrast to the buff coats. We were soon rewarded by the sight of a mother with her cubs resting on the ground, but decided to keep our distance and wait patiently for some activity. Eventually, the mother stood up, stretched and walked across the plain. Only then did I notice the bloody forepaw – proof that she had recently been feeding. Even though I could have used a longer lens to increase the size of the cheetah in the frame, I decided against a tight crop

because I wanted the shadows cast by the rocks to echo the shadow line running down the back of the cheetah's lithe body.

Female cheetah (*Acinonyx jubatus*)
Masai Mara, Kenya, April
Nikon F4, 200–400mm lens, Kodachrome 200

POINT TO WATCH

● *Using a longer lens is a much better option than urging your driver to move in closer to game animals. More natural pictures will be gained – as well as more interesting behaviour – if the animals appear to be relaxed because they accept your presence.*

Anticipating Behaviour

Animal behaviour is one of the most challenging, yet most rewarding, aspects of wildlife photography. Try to anticipate how your subject is likely to behave and react. Where does it feed? Does it go through elaborate, eye-catching courtship rituals to attract a mate? At what time of year are the young born? The more research you do the better.

WHEN I first take a wild animal, my initial objective is to get a sharply defined portrait. My next challenge is to record a moment that encapsulates some aspect of the animal's behaviour. Examples range from a bird calling or a primate pulling faces (depicting pleasure, fear or aggression) to the way animals move, hunt, feed, sleep, play, court, mate and care for their young.

Spend time reading about animal behaviour. Knowing how animals react when faced with a predator, another individual competing for a nest site or a mate will help ensure that you do not miss photographic opportunities. Even when there is nothing worth photographing, I make notes which can be incorporated into books or articles later.

It is crucial to sense the minimum distance you can approach without causing disturbance to a wild animal, which may react either by freezing to the spot, bolting or charging. Knowing how to 'read' the signals of a potentially dangerous animal before it is too late is vital and comes after many hours of observation.

When I stopped to look at a troop of baboons in Kenya, I failed to notice the baby corralled by its mother sitting with her back to us. Typical of all youngsters, it soon became restless and struggled free from its mother to play. This frame shows the mother keeping a watchful eye on her offspring as it plays with a stick. By supporting the camera and zoom lens on a window clamp, I could quickly adjust the focus and framing as the monkeys moved around within their group.

Baby anubis baboon (*Papio anubis*) with mother
Buffalo Springs Reserve, Kenya, April
Nikon F4, 200–400mm lens, Kodachrome 200

POINTS TO WATCH

● *Learn to recognize what different calls mean; agitated alarm calls, for example, are a sure indication that a predator is near by.*
● *A grazing animal that paws at the ground is disturbed; this may be a prelude to a charge.*

Facial Expressions

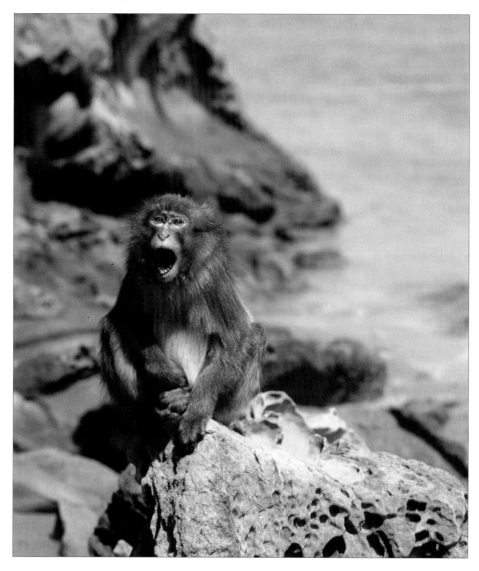

MAMMALS, particularly carnivores and primates which have pliable skin covering their faces controlled by muscles, can adopt a wide range of facial expressions to convey their particular mood. These signals are readily understood by adjacent individuals and, when anger is vented at a photographer approaching too close to an animal's offspring or food, this is a signal to back off. Monkeys use their lips and cheeks, as well as their eyes, eyelids, eyebrows and ears, to convey a gamut of emotions.

Because I had already focused my camera on the Japanese macaque, I was ready when it began to call out in response to young male monkeys chasing youngsters. It was an alarm signal to other individuals within the troop.

Japanese macaque *(Macaca fuscata)* calling
Koshima Island, Japan, April
Nikon F4, 200mm lens, Kodachrome 200

POINT TO WATCH

● *Study animals' facial sign language by observing the subtle changes in attitude of their eyes, mouths and ears and watch how other individuals react. Look up periodically from the camera – this will give you a broader view of the scene and the participants.*

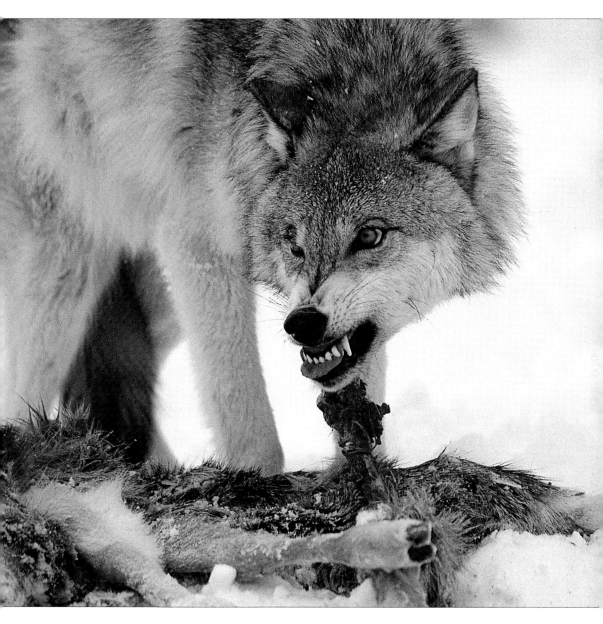

THIS WOLF is snarling in response to another wolf (out of shot) approaching his food – a dead mule deer. The open mouth with the exposed teeth is a typical aggressive signal adopted by canines. On the other hand, an open mouth with the corners retracted and the ears laid back signals fear by a submissive animal.

I was taking pictures of the wolf feeding on the deer carcass when I noticed another wolf approaching. Anticipating a reaction, I focused on the head of the feeding wolf and I was rewarded by repeated snarls. Cropping out the back of the wolf automatically increases the focus of attention on the head.

> **Wolf (*Canis lupus*) snarling (C)**
> Utah, USA, February
> Nikon F4, 200–400mm lens, Kodachrome 200

POINTS TO WATCH

● *Predators become very possessive about their prey and should never be approached at close range when they are feeding on a kill.*

● *If you want to take facial expressions in response to a natural situation, it is most important that your presence is not intrusive. Always opt for the longest lens possible.*

● *If the light is poor and a lens has to be used fully open, make sure that the eyes of the animal, at least, are in focus.*

Moving over Land

THE FEET OF MAMMALS that move over land are adapted to their particular environment and way of life: the thick horny hooves of grazers withstand repeated contact with stony ground, while the padded paws of carnivorous cats allow them to creep up on their prey. Monkeys use their feet and hands both for walking and for grasping branches as they move with great agility along aerial walkways in the trees.

Caribou have broad hooves for walking on snow during harsh Arctic winters. I found the young caribou (right) playfully running to and fro across the Arctic tundra while I was being driven along a gravel road on the Prudhoe Bay oilfield. Two aspects of the scene caught my eye: the body rimlit by the late evening sun (it was 9.30 pm) and the water splashing up from the waterlogged tundra. With the camera already mounted on a window clamp, I could pan and focus it as soon as the vehicle stopped.

> **Caribou calf** *(Rangifer tarandus)*
> Prudhoe Bay oilfield, Alaska, July
> Nikon F4, 200–400mm lens, Kodachrome 200

POINTS TO WATCH

● *Caribou, like African wildebeest, make spectacular annual migrations seeking fresh grazing grounds. Long lines of animals passing overland, often following traditional routes, are equally impressive whether photographed from the ground or from the air.*

● *When one or more animals are running across one side of the frame to the other, gently pan the camera in the same direction as the movement to keep the animals in the frame and allow several shots to be taken.*

● *Never cut off an animal's escape route – for their and your own safety.*

● *Never feed wildlife; this may attract predators into the area.*

● *If animals move off before you can get a picture, look for their tracks which show up best on soft ground with no vegetation – particularly when low-angled available lighting accentuates the impressions of their footprints.*

WILD SHEEP AND GOATS are agile, sure-footed animals that can negotiate precipitous slopes and the narrowest of ledges with ease. Attempting to compete with their agility is both a fruitless and dangerous exercise. My approach is to take a roundabout route up a mountain – preferably downwind of them so that they do not scent me – until I can shoot on a level with them or, as in this case (opposite), work from a road with a long lens. Even though this location is a well-known one for viewing Dall's sheep, I had passed it on three previous days without a sighting. On this occasion, a gaggle of cars parked haphazardly alerted me to take a close look. I had only just set up my long lens on a tripod when three sheep zigzagged their way down the rock face, their white bodies picked out by the backlighting. I could not have wished for the positions of the sheep to be more harmonious, but almost as soon as I had captured it, the design was spoilt as the top two sheep merged with the lower one. This just goes to prove that a picture can succeed or fail as a result of split-second timing. Many fine shots are missed simply by having to spend time changing the film.

> **Dall's sheep** *(Ovis dalli)*
> Anchorage to Seward Road, Alaska, USA, July
> Nikon F4, 200–400mm lens, Kodachrome 200

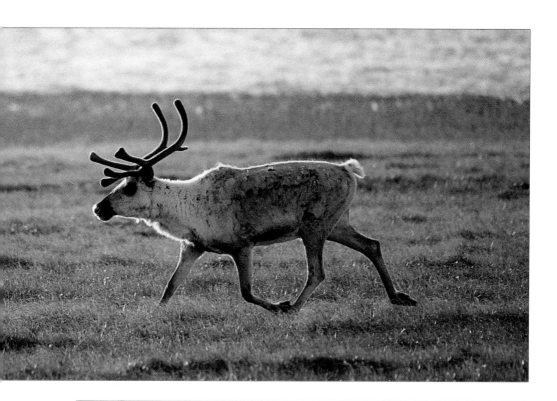

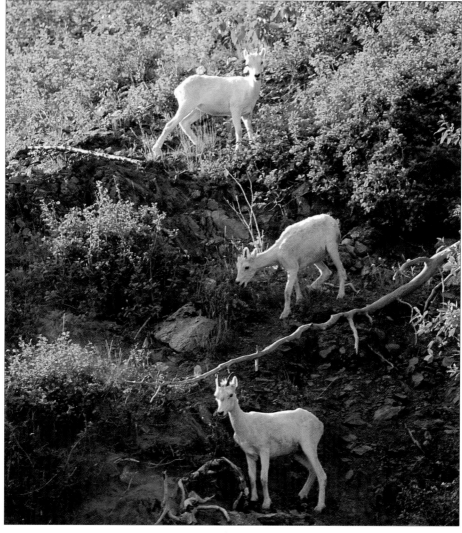

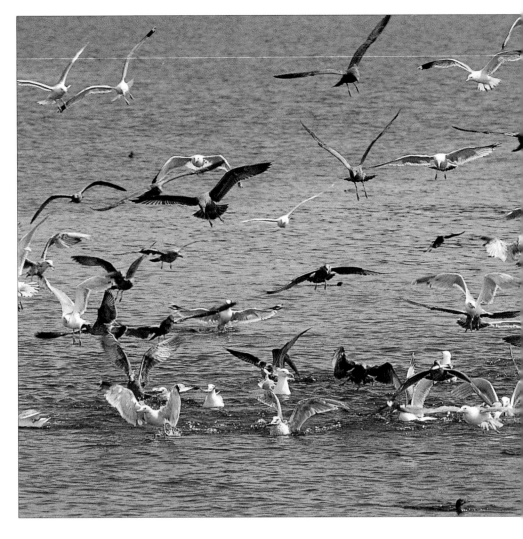

BIRDS CAN BE PHOTOGRAPHED in flight almost anywhere – over land, water or sea – but the easiest places are where they congregate to feed, as they fly to and from their nest site or where they follow regular flight paths. Coastal clifftops above sea-bird colonies are good places to take birds as they soar above the cliffs on updraughts. In places where birds are flying across in front of the camera, there will be time to focus the lens manually. However, a much greater proportion of sharply focused shots of a single large bird will be gained by using an auto-focus lens. Cameras with predictive auto-focus control are a great boon when taking birds flying head-on.

Once the camera has locked on to the subject, a sequence of pictures depicting successively larger images can be obtained; with manual focusing, only a single image will be possible.

Japanese nature photographers, familiar with the flight paths of cranes, drove me to a farmhouse where several other photographers had already assembled. We did not have long to wait before the cranes appeared as specks in the distance. By metering off the orange after-glow of the dusk sky, the birds were rendered as simple silhouettes.

> **Japanese cranes (Grus japonensis)**
> Hokkaido, Japan, February
> Nikon F4, 80–200mm lens, Kodachrome 200

POINTS TO WATCH

● *When taking massed birds in flight, an auto-focus lens may create more problems than focusing manually.*

● *If the birds cannot be isolated against sky or water, pan the camera to blur the background.*

Flying through Air

I WAS ON A WHALE-WATCHING TRIP when I came across a feeding frenzy of birds diving repeatedly on a herring ball (below) – a marvellous example of dynamic aerobatics as the birds homed in from all directions. Because I was in a moving boat and I wanted to freeze all movement of the wings, ideally I would have chosen the fastest shutter speed possible (1/1000 second with an f5.6 lens). But, since the birds were not in a single plane, I knew I could not afford to shoot with the lens wide open without risking many birds being out of focus; I therefore opted for 1/500 second shutter speed with an aperture of f8.

Birds feeding on herring ball
British Columbia, Canada, July
Nikon F4, 100–300mm lens, Kodachrome 200

POINTS TO WATCH

● *When taking massed birds in flight, an auto-focus lens may create more problems than focusing manually.*

● *A tripod may be too inflexible for taking birds flying in front of you. Use a shoulder pod to brace a camera with a long lens.*

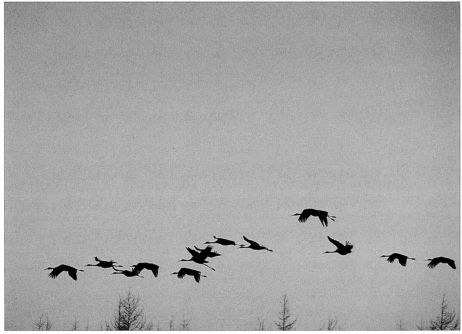

Swimming through Water

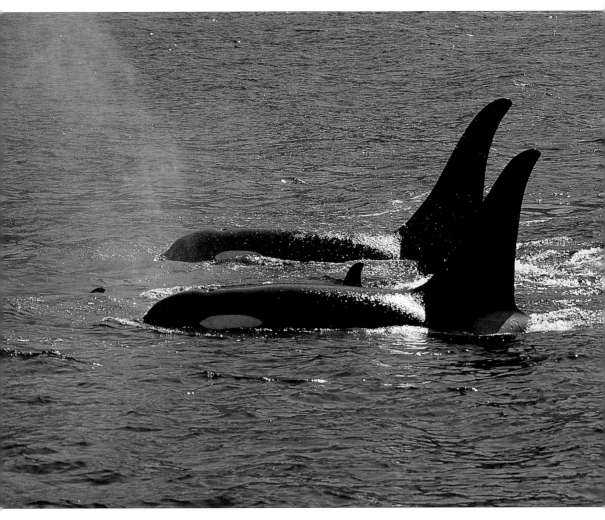

ANYONE who is prepared to spend time scanning the sea surface where marine mammals are known to appear will be rewarded with shots of the animals emerging from the water. Even though birds also move in a three-dimensional environment they can, at least, be seen before they reach photographable range. Marine mammals, on the other hand, may give little warning of their whereabouts before they surface. Once a whale blows, however, this gives a point on which to focus since it usually blows several times before it dives.

Killer whales or orcas have a black pointed dorsal fin that cuts scimitar-like through the water. An excellent location for watching and photographing orcas is Robson Bight in Canada where they have been studied intensively. Since these whales live in matriarchal groups or pods, it is not difficult to get photographs of several whales in the same picture. The blow (a mix of air and water) shows up best when viewed against the light.

Pod of orcas or killer whales (*Orcinus orca*)
Robson Bight, British Columbia,
Canada, July
Nikon F4, 100–300mm lens, Kodachrome 200

POINTS TO WATCH

● *Use a zoom lens to save time changing focal lenses when the action takes place. Keep a short zoom lens on a second body in case a whale surfaces alongside the boat.*

● *When standing on a moving boat, use a monopod to relieve the weight of a long lens.*

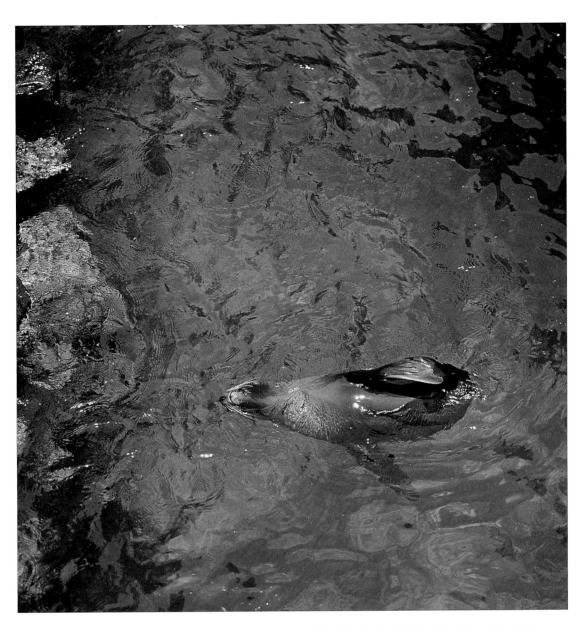

S EALS AND FUR SEALS all spend time hauled out on land but, unless a pair of bulls are fighting to defend their territory, they are not particularly active. However, once they enter the water their bodies can twist and turn with the agility of a gymnast. Unlike whales they do not blow, so one moment heads are bobbing above the waves while the next all trace has gone as their agile bodies snake beneath the surface. These fur seals were resident in a grotto formed from a large laval tube where their playful frolics were within easy camera range from surrounding rocky shelves. Even so, I had to wait until the fur seals were not swimming over one another so that the shape of the bodies and flippers were clearly defined by the surrounding blue water.

Fur seal *(Arctocephalus galapagoensis)*
Isla Santiago, Galapagos Archipelago, December
Hasselblad 500 C/M, 150mm lens,
Ektachrome 64

POINTS TO WATCH

● *Wear Polaroid sunglasses to remove the skylight reflection to get a better view of whales or dolphins just below the water surface.*

● *Use a polarizing filter to photograph marine mammals just below the water surface. When working from a small boat or a kayak, protect all gear not in use from sea water spray in case a whale comes in close and slaps its fins sharply down on to the water.*

● *A magical time to photograph any whale surfacing is when the sea is lit by the glow from a pre-dawn or a post-dusk sky.*

Feeding Strategies

GRIZZLY BEARS, photographers and fishermen congregate when the salmon run up Brooks River in Katmai National Park. An elevated platform provides a safe viewpoint overlooking the falls, where the different fishing techniques can be observed. Young bears (right) expend much energy splashing around without a great deal of success, whereas an experienced adult male will wade in, submerge and invariably surface with a catch. Some catch a fish simply by scooping it up with their clawed paws; others wait at the top of the falls for a fish to leap near their ever-open jaws. A bear that makes repeated attempts to pounce on a fish offers more photo opportunities than a speedy snatcher.

While other photographers were focusing on bears above the falls, I spotted one climb on to a mossy rock across the far side of the river. The rivulets of water draining off the fur as the bear emerges triumphant with his catch make this my favourite picture of a bear feeding.

> **Brown bear *(Ursus arctos)* with salmon**
> Katmai National Park,
> Alaska, USA, July
> Nikon F4, 500mm lens, Kodachrome 200

POINT TO WATCH

● *White water functions as an effective reflector, so the safest way of metering is to spot-meter off the bear's sunlit flank.*

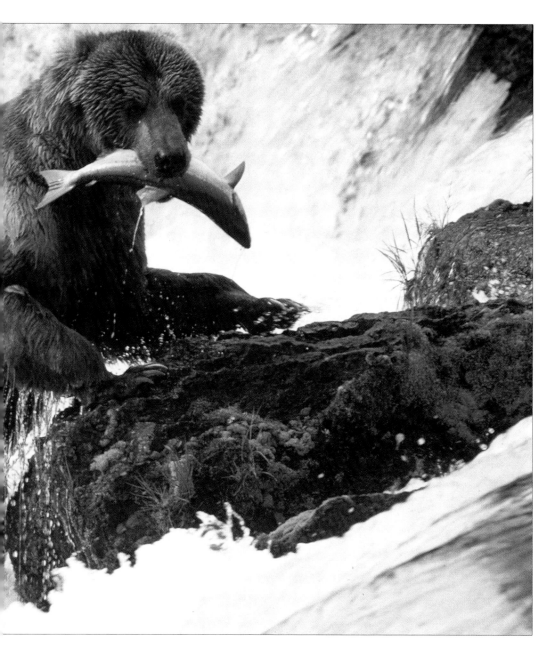

AFTER THE BEARS have devoured several complete salmon, they continue to catch fish, skin them and eat only the nutritious brains which help to build up their fat reserves for the onset of winter.

Discarded fish dropped into the river are swooped upon by gulls, while fish dumped on land are rich bounties for terrestrial animals. When I noticed a red squirrel (opposite) approach a fish dropped close to the viewing platform, I quickly changed to a shorter lens to record the opportunist scavenger feasting on the red salmon flesh.

Red squirrel (*Tamiasciurus hudsonicus*) feeding on salmon
Katmai National Park,
Alaska, USA, July
Nikon F4, 80–200mm lens, Kodachrome 200

POINTS TO WATCH

● *Even with a continuous action tableau, it pays periodically to take your eye from the viewfinder and glance around to see what other wildlife may be in the area.*

● *Each salmon run has a narrow time slot, so ring a park ranger beforehand to check.*

Courtship Rituals

COURTSHIP RITUALS range from one male displaying (see page 97) to one or more females, to massed courtship extravaganzas involving many individuals – which provide opportunities for photography over longer periods.

I had photographed huge concentrations of flamingos in East Africa's Rift Valley lakes before but, on a recent trip, I was intrigued to see the uniform pink bands punctuated by deep pink patches as groups of birds moved into a tight pack and began stomping around with erect necks. I later learnt that flamingos perform this ritualized part of their nuptial display in large numbers. Even though there was plenty of light, the ISO 200 film allowed me to use a fast shutter speed and to stop down well to gain a good depth of field.

The size and shape of the communal stomp constantly changed as birds left and joined the group.

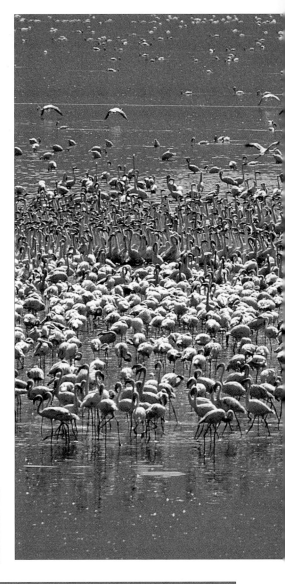

Marching display of lesser flamingos
(Phoenicopterus minor)
Lake Bogoria, Kenya, April
Nikon F4, 200–400mm lens, Kodachrome 200

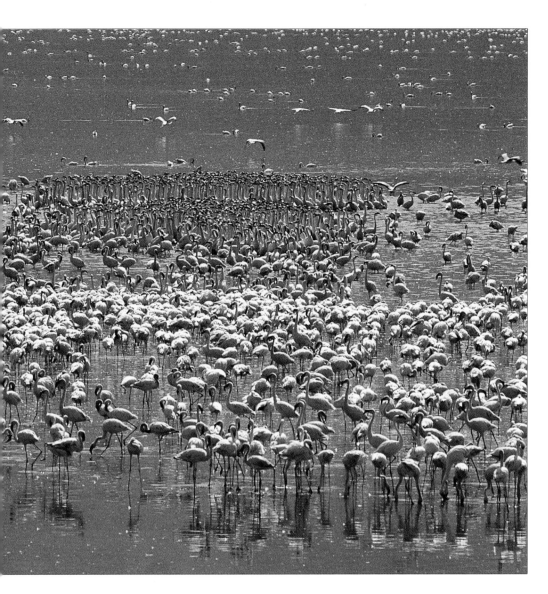

Y OUR CHANCES of recording ephemeral courtship behaviour will be increased if you know when it is most likely to occur. Even so, if the trigger is temperature or weather dependent, the actual time when frogs gather to breed may vary from one year to another.

The picture opposite exemplifies the point that it is not always necessary to travel far afield to wilderness areas in search of memorable images. I knew from my efforts of taking frogs in previous years that any sudden jerky movements – including moving the hand away from the camera to recock a manual wind-on – would be enough to cause the frogs to duck beneath the surface. To increase my working distance, I opted for a 200mm rather than a 105mm macro lens to take a male frog clasping on to a mating pair. I decided against using a polarizing filter because I wanted to retain the silvery skylight reflection on the water in order to highlight the beady eyes breaking the surface and to render the bodies under-water as ghostly images.

Frogs (Rana temporaria) in amplexus
Garden pond, Surrey, UK, March
Nikon F4, 200mm macro lens,
Kodachrome 200

POINT TO WATCH

● *Sometimes animals may be so engrossed in their courtship that nothing will distract them; none the less, take care not to cause any distur-bance, since energy wasted by moving away may be energy lost for successful breeding.*
● *Keep your movements to the minimum by using a motor-driven camera on a tripod or a monopod. If you have to move, do so slowly.*

Young Animals

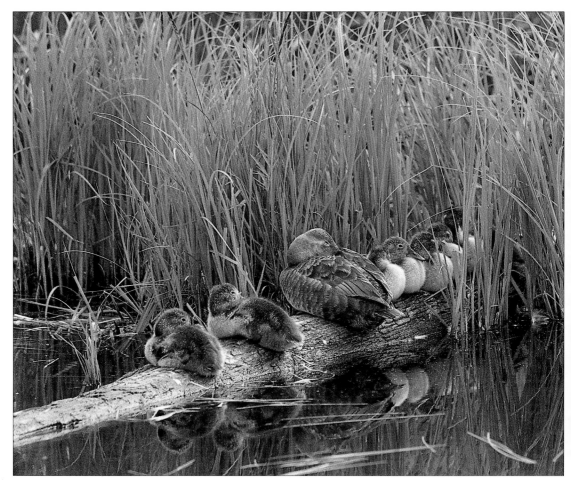

MANY YOUNG ANIMALS, notably fluffy chicks of geese and swans as well as kitten-like cubs of wild cats, have universal appeal; but they are at their most photogenic for only a limited period, so I always research the time when a species is most likely to breed. In temperate regions this is usually in the spring, when insect life is plentiful for birds to feed their helpless nestlings and fresh grass supports young herbivorous animals.

The survival rate of young animals determines the litter size and the degree of parental care and attention. Birds such as geese produce large clutches, because only a few young will survive to reach maturity. Primates, on the other hand, have a high survival rate and produce one (occasionally two) offspring which is suckled and cared for over a long period. During the time young animals are dependent on one or both parents there is plenty of scope for enchanting pictures of the bonding between them.

The duck family above was an opportunist shot seen at a roadside wetland reserve. I took a few frames before another car stopped – no doubt attracted by my long lens – and the driver leapt out, disturbing the ducks which swam off into the reeds.

Female canvasback (*Aythya valisineria*) with family
Potter Marsh, Alaska, USA, July
Nikon F4, 200–400mm lens, Kodachrome 200

POINT TO WATCH

● *Remember that young animals are very vulnerable to attack by predators, so never jeopardize their safety by approaching so close that they get separated from their parents.*

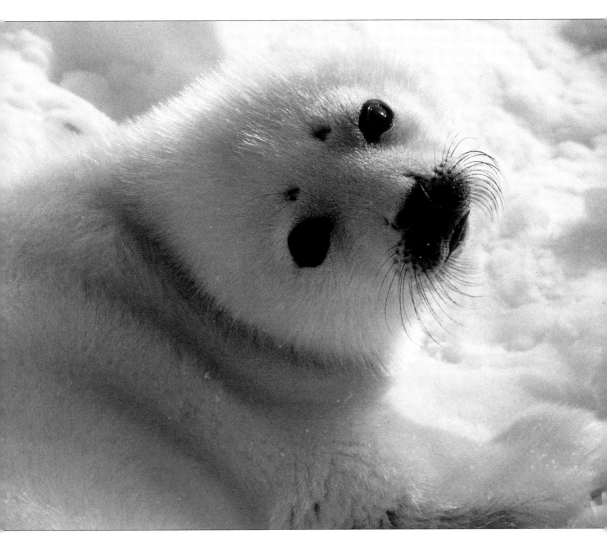

HARP SEALS give birth to their pups, known as yellowcoats, on floating pack ice. After three days, the fur turns white; by the time these white coats are a week old, they are at their most appealing with black eyes staring out from white fur. Not so many years ago, however, the young seals were slaughtered for their pelts.

To reach the ice I took a helicopter flight and on landing I repeatedly checked the thickness by prodding the ice with my tripod. White ice is safe, whereas grey ice is thin. The ice moves constantly, resulting in the formation of open water channels, known as leads. When the wind blew, the temperature fell to -20°C, so I was glad the camera was powered by a remote-control cold-weather battery pack tucked inside my anorak.

The pups lie low, their warm bodies melting a hollow, known as an ice cradle, in the ice. To highlight the dark eyes and moustache I crouched on the ice to gain a low camera angle. I avoided taking the pup in direct sunlight because I wanted to show detail in the white fur. To ensure the correct exposure, I spot-metered off a shadow area on the ice.

Harp seal pup *(Phoca groenlandica)*
Gulf of Saint Lawrence, Canada, March
Nikon F3, 200mm lens, Kodachrome 200

POINTS TO WATCH

● *The appeal rating of any baby animal portrait is greatly enhanced by eye-to-eye contact, as shown here.*
● *With only a single offspring, the scope for varying the composition is more limited than when many young are produced, although the seal pups can be taken as they suckle.*

Capturing
Movement

*Movement can be portrayed in a still photograph by
using fast or slow shutter speeds, multiple exposures,
photo sequences or by means of flash or time lapse.
The most appropriate technique will, to a large extent,
be determined by the speed and longevity of the movement.*

THE SIMPLEST WAY of recording move-
ment is to use a fast shutter speed
when there is plenty of light available
and the film speed is fast enough to al-
low a shutter speed of 1/500 to 1/1000
second to be used. Then, the actions of
many animals – apart from the rapid
wing beats of humming birds and
insects – will be stopped. The main
concern is to ensure that the entire
animal appears within the frame and
that wing tips or legs are not cropped.

Flash will also freeze motion, al-
though when used in the field during
the day it needs to be balanced with
the available light – otherwise the
background will be underexposed.

Capturing motion as a sequence
with a motor drive can provide more
information about the way a mammal
runs, a bird flies or a whale dives than
a single-frame image. But it is a fallacy
that the best way to freeze the peak of
the motion is to use the continuous-
exposure mode because, even with the
fastest motor drive, it is still possible
to miss the prime moment. It all

depends on the speed of the action.
Often I opt for the single-frame mode
and wait for the optimum time to
release the shutter, because many
dupes of a perfect shot are more useful
than several mediocre originals. This
approach also ensures that I do not
run out of film at the crucial moment!
Whenever I see a large terrestrial
mammal submerge into water, I try to
anticipate the moment when it will re-
emerge. It is very tiring to hand-hold a
camera with a long lens at the ready,
so for the shot of the grizzly bear I
mounted the camera on the tripod.
By loosening the tripod head, I could
gently pan the camera to keep the bear
in the viewfinder ready for the moment
when it stood up. Then, by using the
shutter-priority mode, I froze the water
draining from the outstretched arms.
A sunny day helped to add sparkle to
the rivulets and droplets.

> **Grizzly bear** *(Ursus arctos)* **(C)**
> Utah, USA, June
> Nikon F4, 200–400mm lens, Kodachrome 200

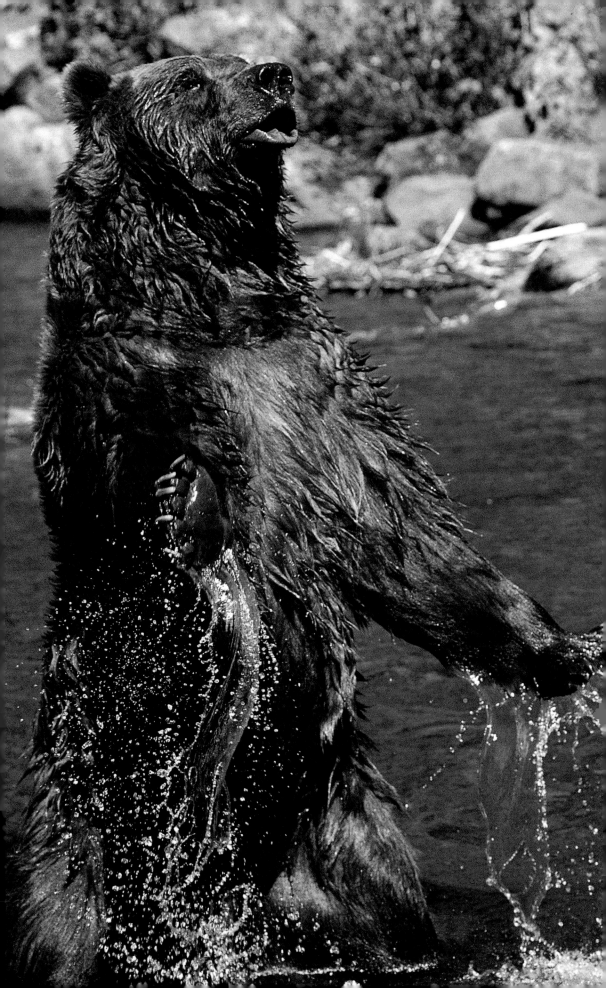

Fast Shutter Speeds

P LENTY OF LIGHT or a fast film are essential when using fast shutter speeds to arrest rapid movements. Even though there was a reasonable amount of light, because both the boat I was in and the dolphins were moving, I opted for a medium-fast film so that I could use a shutter speed of 1/500 second, coupled with an aperture of f8. Achieving a sharp picture of leaping dolphins requires a combination of concentration, perseverance and, not least, luck. With clear water and a high vantage point, I can often spot a dolphin swimming underwater just before it breaks the surface.

Common dolphins *(Delphinus delphis)*
Sea of Cortez, Baja California, Mexico, March
Nikon F4, 100–300mm lens,
Kodachrome 200

POINTS TO WATCH

● *When the light varies, use the shutter-priority mode to maintain a fast speed yet allow the aperture to change with the light level.*
● *When working on land, compare the effect of using a fast shutter speed with a slow one when panning the camera.*

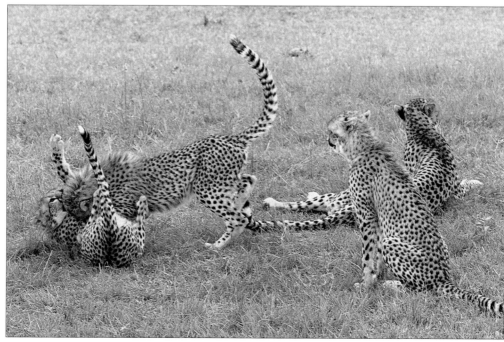

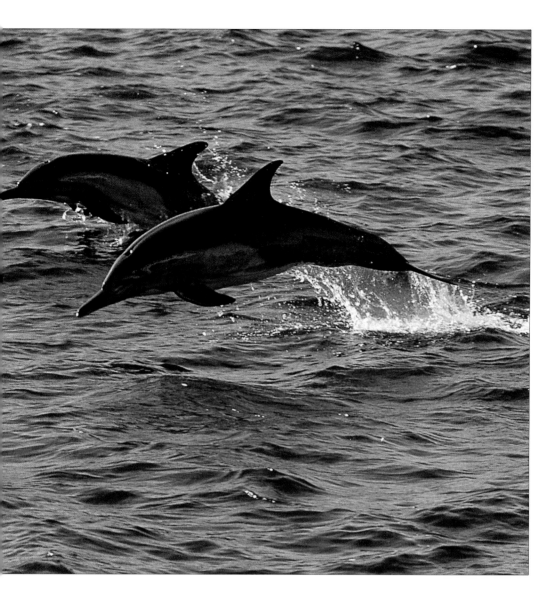

F OR A FEW EXHILARATING MOMENTS, I re-
corded cheetah cubs frolicking as they
tumbled over one another on the African
plain, their tails flying in all directions
(opposite). Knowing that I had frozen the
action with a fast shutter speed (1/500
second) I was confident that I had some
exciting action shots, so I was bitterly
disappointed when I discovered that this
film was one of several which had effect-
ively been overexposed by several stops
as a result of a processing problem.

Not so many years ago, these frames
would have been lost for ever, but the
original colours were restored by means
of computer enhancement using the true
colours from my static cheetah shots.

The image reproduced here is from a
copy made from an enhanced image. The
composition would have been stronger
had the two cubs on the right been out of

shot. I did try zooming in, but the upright
tail meant that I would have had to include
the foot and tail of the cheetah lying on
the ground which was worse than cutting
the tip of the tail on the extreme right.

Cheetah *(Acinonyx jubatus)* cubs
Masai Mara, Kenya, April
Nikon F4, 200–400mm lens,
Kodachrome 200

POINTS TO WATCH

● *For a given light level, a fast lens will allow
a faster shutter speed to be used.*
● *If you want to use a faster shutter speed
than the light allows, either use a faster film
(higher ISO number) or 'push' the speed of
the entire roll by 1–2 stops. Mark the speed at
which you rated the film clearly on the
cassette so that it is processed correctly.*

Freezing with Flash

FLASH IS AN INVALUABLE TOOL for freezing action in low-light conditions when it is inappropriate to use a high-speed film. I use it for photographing small animals scurrying over the bottom of rockpools, nesting birds overshadowed by vegetation or rocks, fast-moving insects and nocturnal animals (see page 47).

A snake's flickering tongue is slow enough to be perceived by a human eye, but even with a fast shutter speed, the tip is invariably blurred. For this shot of an adder 'tasting' its surroundings I used twin flashes, mounted each side of the camera on a flash bracket. Taken many years ago with manual flash units, I had to calculate the exposure.

THE REED WARBLER'S NEST was low down in the reed bed so, to get this picture, I used two flashes – one on each side of the nest – to freeze the sudden upthrusting of the chicks' gaping mouths. I fixed each flash (connected to the camera via long extension cords and a twin flash connector) to a Benbo tripod outside a hide already in position. Conventional lighting stands are a liability when working on uneven terrain – I once wrote off a flash when a stand fell into water. Inside the hide, I checked the exposure and depth of field, as well as the light and shadows, by exposing a Polaroid print on my Hasselblad back before shooting transparency film.

Adder or viper *(Vipera berus)*
Thursley, Surrey, UK, June
Nikkormat FTN, 135mm lens,
Kodachrome-X (ISO 64) with twin flash

**Reed warbler *(Acrocephalus scirpaceus)*
feeding chicks in
reed *(Phragmites australis)* bed**
Gravel pit, Buckinghamshire, UK, June
Hasselblad 500 C/M, 150mm lens,
Ektachrome 64

POINT TO WATCH

● *Avoid using on-camera flash to light shiny or wet surfaces as it will reflect back into the lens. Either move the flash to one side of the camera or use a diffuser on the flash.*

POINT TO WATCH

● *Use rechargeable nickel cadmium batteries for extended flash work. This makes both environmental and economic sense.*

Blurring Motion

THERE ARE two ways of blurring motion in a moving subject. One is to use a shutter speed that is too slow to freeze the image. The other is to pan the camera; the subject remains sharp but the background and the vertical elements of the animal's movements are rendered as fluid lines, which helps to enhance the impression of speed. The wolf was taken by slackening the locking screw on the tripod head so as to allow a smooth pan in the direction of the moving animal. I always try to compose so that the space in front of the animal is greater than the space behind it as this makes for a more dynamic composition.

> **Running wolf** *(Canis lupus)* **panned (C)**
> Utah, USA, October
> Nikon F4, 200–400mm lens, Kodachrome 200

POINT TO WATCH

● *Pan the camera at a constant speed and continue moving it after the shutter is released to ensure no jerkiness will result.*

IN THE MID-1950S, the discovery that a troop of Japanese macaques regularly took a sauna in natural hot pools on the island of Honshu made world headlines. I was intrigued to see the way the monkeys entered the water. Old females gradually lowered their bodies into the warm water, making sure that their heads remained dry, while youngsters leapt into the air and landed on the water in a tucked position with a big splash. Wet, bedraggled monkeys emerged with their hair plastered against their skeletal-looking bodies, yet a few quick shakes of the head, followed by a natural blow-dry, soon restored their normal appearance.

As part of a photo story, I wanted to illustrate how the young macaques removed surplus water from their fine, hairy bodies. Some shook their heads as soon as they surfaced, while others climbed out before shaking themselves.

Unlike the wolf shot, the tripod mount was secure on the tripod because I wanted to contrast the blurred motion of the monkey's head with its static body. A shutter speed of 1/30 second recorded the wet head hair as swirling lines and the water drops as lines of bright dashes flying out in all directions, reminiscent of an exploding firework.

> **Japanese macaque** *(Macaca fuscata)*
> Shiga Heights, Japan, April
> Nikon F4, 200mm lens, Kodachrome 200

POINTS TO WATCH

● *Check the background for distracting elements such as tree trunks which will not be blurred if the camera is fixed. Unless the light is dim, a slow shutter speed will determine a small aperture for correct exposure, causing even distant background elements to appear clearly in focus.*
● *Avoid cropping too tightly on the animal's head, otherwise the extremities of the radiating lines of water may be lost.*

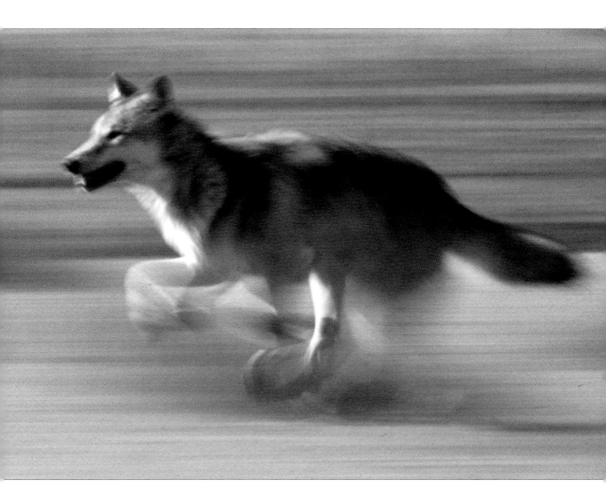

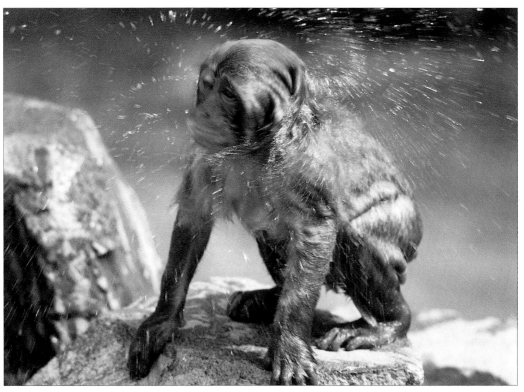

Photo Sequences

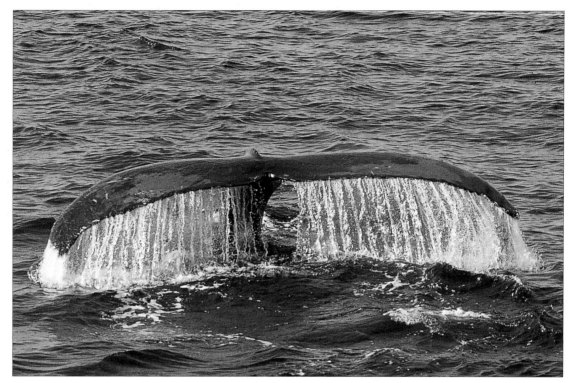

THE WAY in which a mammal moves or a bird flies can best be appreciated by studying a series of pictures taken in quick succession. During the last century, when Eadweard Muybridge began his classic and painstaking photographic studies of animal and human movement, he used twelve cameras – triggered sequentially – to settle an argument that a galloping horse lifts all four feet off the ground at the same time. Nowadays, however, many actions can be recorded simply by using a camera with an in-built motor drive, although high-speed flash will be needed to freeze fast-flying insects and birds.

The time between a humpback whale's tail emerging and disappearing prior to a dive is sufficiently long for several frames to be taken with any type of modern motor drive. The time interval between individual frames needs to be chosen so that each phase of the movement is different from the previous one. Since a whale tends to surface and blow several times before it finally dives, you can determine the approximate focusing range, and therefore the best focal length of lens

to use, before you switch on the motor drive and expose any film.

For capturing a photo sequence of a diving whale, I keep two cameras – each with a long-focus zoom – set on continuous motor drive which, with the basic battery pack for the Nikon F4, fires at four frames per second.

Humpback whale *(Megaptera novaeangliae)* **tail flukes sequence**
Johnson Strait, British Columbia, Canada, July
Nikon F4, 100–300mm lens, Kodachrome 200

POINTS TO WATCH

● *It is a false economy to save the last few frames. Before the action begins rewind and load with a fresh film.*

● *When framing the first shot of a sequence, make sure there is plenty of space all round the subject, because the magnification cannot be altered at any stage in mid-sequence.*

● *To take a sequence of an animal moving in towards the camera, use predictive auto-focus to ensure that the animal remains in focus.*

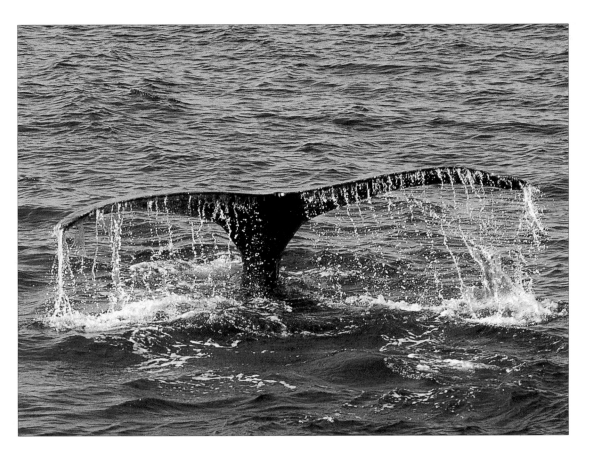

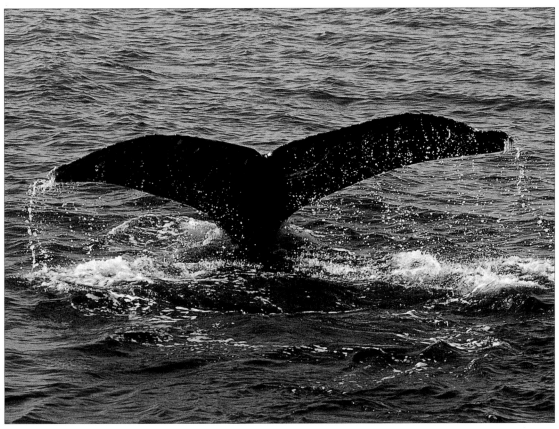

Plant Movement

THERE IS A MISPLACED BELIEF that plants do not move unless they are blown by the wind. This simply is not true. Some plants make sudden and spectacular movements in response to touch. If an insect touches hairs inside the Venus fly trap, for example, it triggers the snapping mechanism of the trap; the squirting cucumber has explosive fruits that eject seeds as they fly off their stalks. Many plants make slower movements, and a sequence of frames, taken at regular timed intervals to depict this movement, is known as time-lapse photography.

Monkey flowers have a bilobed sensitive stigma which protrudes forward in readiness for a visiting insect to deposit pollen on it. When the stigma is touched the two lips close and, if pollination occurs, remain closed; otherwise they slowly open again. The pair of pictures (below) was taken outside, using direct sunlight shining on the back of the flower with a black velvet-covered board behind. I spot-metered off the red petals on which minute hairs have been revealed by backlighting.

> **Monkey flower (Mimulus cardinalis)**
> **Below left: receptive stigma**
> **Below right: stigma closed**
> Garden, Surrey, UK, July
> Nikon F4, 105mm macro lens,
> Ektachrome 100 Plus

POINT TO WATCH

● *On cameras with a multiple-exposure facility, a series of plant movements can be recorded on a single frame. So that the background does not appear overexposed, use a black velvet backdrop.*

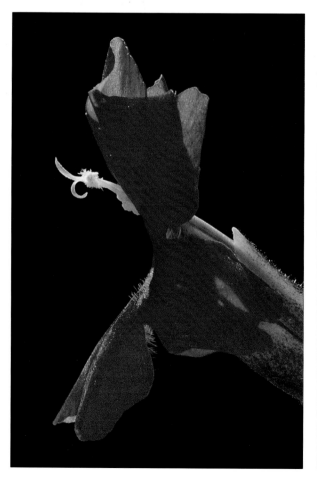
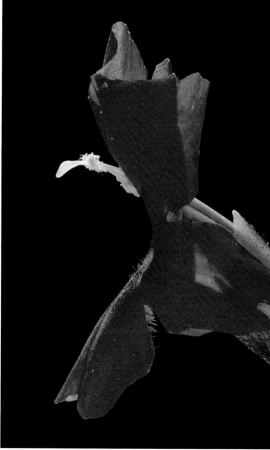

EVENING PRIMROSE FLOWERS open at dusk; indeed, in China they are known as moon flowers. By late in the day you can tell which buds will open that evening because, as the base of the protective sepals splits open, the yellow petals begin to show. Well before the bud opens, I select one at my eye level with the least cluttered background. When I frame the first picture in the sequence, I make sure that there is plenty of space around the bud to allow the flower to open fully without the edges of the petals being cropped out of the later frames. In midsummer, the first buds begin to open around 8.30 pm when, provided there is no wind, there is enough available light to make an exposure without flash on a slow film. If you happen to select a flower that opens later, however, the light will have dropped and a fill-flash will be needed.

Once you have begun taking a sequence, it is then too late to change to another flower that evening. On several occasions I have shot the first frame only to find that the flower did not open as I had expected and there was not a clear view into the centre. When the sepals bend back, the petals untwist and open within seconds.

> **Evening primrose** *(Oenothera* sp.)
> **Left: bud. Right: open flower**
> Garden, Surrey, UK, July
> Nikon F4, 105mm macro lens,
> Ektachrome 100 Plus with fill-flash

POINTS TO WATCH

● *Select a viewpoint with a simple background or use a board sprayed green and brown – like a natural backdrop.*

● *Use a plant clamp, made from two knitting needles, to steady a moving plant stem. Push one needle into the ground and use plasticine to fix the other at an angle and an opened paper clip at one end to hook on to the stem.*

I AM ALWAYS ON THE LOOKOUT for subtle and ephemeral changes that will magically transform a mundane scene into an exciting photo opportunity. One animal reacting to another, a mother responding to her offspring or a group of grazing animals looking up and turning their heads in unison alerted by a sudden noise – all provide opportunities for gaining pictures with a great sense of vitality.

To capture such moments you must be constantly alert to every possibility. Instead of keeping your eye glued to the viewfinder, look around periodically, survey the scene and listen out for telltale sounds such as an approaching competitor or predator which might provoke a reaction from your subject.

Early morning is an excellent time to gain unusual pictures of diurnal animals reacting to one another as they become active at the dawn of a new day. Alerted by the marmots' chattering, I instinctively panned the camera away from a group of male deer to catch the pair of marmots, rimlit by the low sun, greeting each other.

Olympic marmots (*Marmota olympus*)
Olympic National Park,
Washington, USA, July
Nikon F4, 500mm lens, Kodachrome 200

The Fleeting Moment

IN ALL MY VISITS TO AFRICA, I had never seen such a small baby elephant. Probably no more than a week old, it still wasn't sure what to do with its trunk and kept shaking it. The youngster kept very close to its mother and fed repeatedly. As the mother was also feeding, she periodically moved forward to find fresh grass – lush from recent rains – so the suckling ceased. It was during one of these inactive periods that I suddenly saw the baby completely framed by the mother's belly and her legs, yet clearly isolated from her body by the green grass behind. I was able to take only one shot before the perfect framing was ruined by one animal moving very slightly.

There was no way that I could have planned for this picture, but as soon as I saw the potential I was very excited. It conveys several aspects within a single frame: the diminutive size of the baby, exaggerated by the massive bulk of the mother, and her protective attitude – she is clearly shielding it from danger.

> **Baby elephant (*Loxodonta africana*)**
> **framed by mother**
> Masai Mara, Kenya, April
> Nikon F4, 80–200mm lens, Kodachrome 200

POINTS TO WATCH

● *To capture a fleeting moment for ever on film, it is essential to work instinctively with a well tried and tested camera system. Never buy a new camera before going on a trip of a lifetime without putting at least one film through it.*

● *Get into the habit of reloading film as soon as a roll is exposed, then there will be no chance of missing an ephemeral event.*

Intimate
Details

*The natural world is a rich reservoir for eye-catching close-ups,
including straightforward record pictures, action shots and abstract
studies in shape, texture, pattern and design. Above all, this aspect of
nature photography requires a critical eye, careful focus, selective use of
depth of field as well as special lighting techniques.*

CLOSE-UP PHOTOGRAPHY not only allows for small subjects – such as insects, flowers and leaves – to fill the frame, but also offers a new perspective on larger subjects, for example, by highlighting the colour and shape of reptilian or fish scales, and of feathers (page 59). The easiest way of focusing a lens at close range is simply to add a close-up lens to the front of a prime lens. This has the advantage of no loss in light and is ideal for larger flowers or groups of leaves. Macro lenses, on the other hand, enable you to get much closer – many giving a life-size image on film. I have three macro lenses – 55mm, 105mm and 200mm – but the 105mm is my favourite because the working distance is twice as great as for the 55mm lens (which means that insects are less likely to be disturbed); and it focuses down to life size without any additional extension. The 200mm macro is ideal for taking active insects such as dragonflies and butterflies. To gain larger than life size magnifications, I use a bellows extension with a macro

lens; but since the depth of field is then reduced, I tend to use this set-up only in a studio.

To get the film plane parallel to the wings and body of the dragonfly opposite resting on a iris in our garden pond, I had to stand on a stepping stone in the centre of the pond and immerse my Benbo tripod legs in the water (the unique design, with the widest leg sections at the base, allows the tripod to be immersed up to a depth of 21 inches).

When a lens set at its maximum aperture is focused, only a single plane will appear sharp but, by stopping down the lens, the amount in focus – the depth of field – is increased. On checking the focus of the dragonfly and the background by using the depth of field preview button, I decided to open the aperture to f8 so that the stone behind the dragonfly would be out of focus.

Male broad-bodied libellula dragonfly
(Libellula depressa)
Garden pond, Surrey, UK, May
Nikon F4, 200mm macro lens, Kodachrome 200

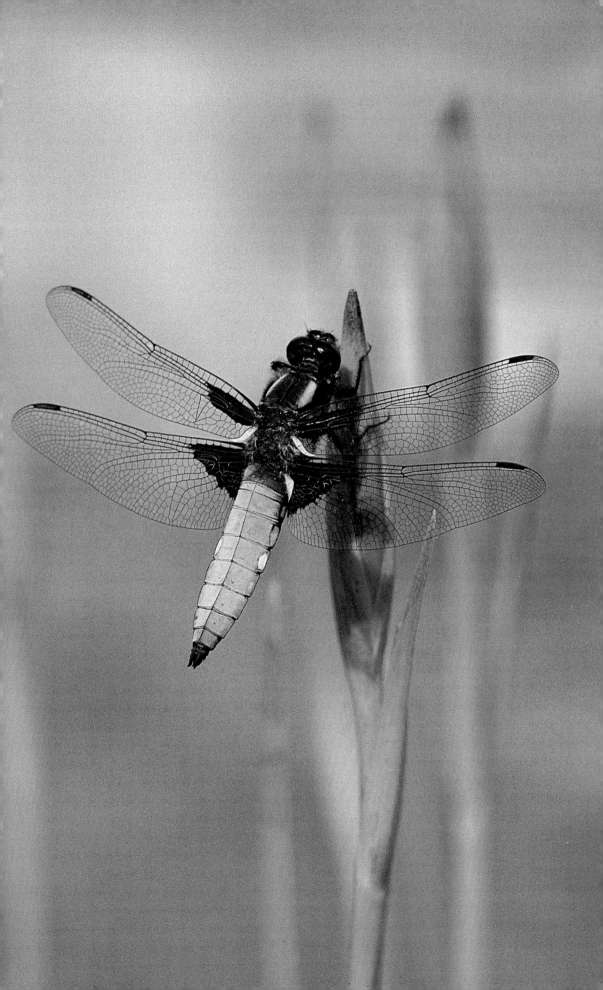

Isolating the Subject

WHENEVER I take close-ups, I always search for ways of isolating the foreground subject from the background so that it will provide greater impact. Early or late in the day, when the sun is shining, conspicuous shadows cast onto sandy areas or snow-covered ground are invaluable for separating sunlit plants. Without the shadow behind them, the pale-toned grasses in this shot would have blended in too well with the snow. In this case, the shadow also contributes to the

composition. If there is no convenient natural shadow behind a sunlit subject, I use a person or my rucksack to create one.

Grasses with ice crystals on snow
Canyonlands, Utah, USA, January
Nikon F3, 105mm macro lens, Kodachrome 25

POINT TO WATCH

● *Use the depth of field preview button to check that there are no distractions in the background.*

HAVING DRIVEN for hours across a featureless desert to reach a solar energy site before sunset, my spirits were lifted by a field of glowing daisies. I abandoned my goal to make the most of this opportunist shot. A wide aperture ensured that the flowers behind were thrown out of focus and simply echoed the yellow.

Black-eyed Susan (*Rudbeckia sp.*)
Taft, California, USA, October
Nikon F4, 105mm macro lens, Kodachrome 25

POINT TO WATCH

● *When backlit, autumnal leaves and yellow, orange or red flowers with petals arranged in a single plane separate well from the background so that they appear to glow.*

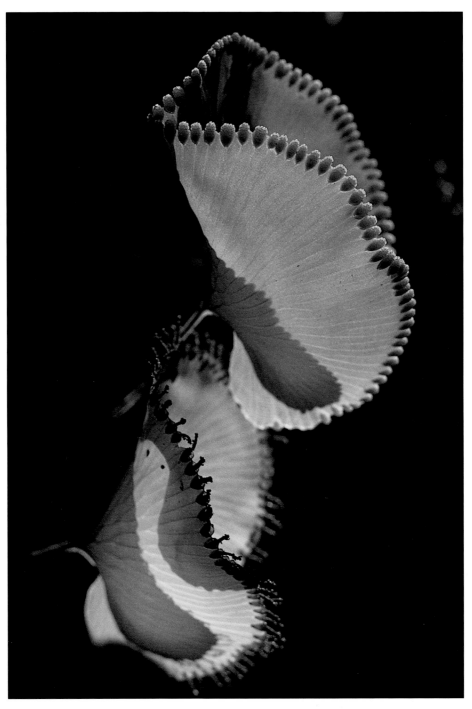

A MOST DRAMATIC WAY of isolating plants is to shoot them with light shining through translucent leaves or petals so that they glow in contrast to an unlit background. Ferns typically seek shade inside forests, so if they are lit by direct sunlight it will be for only a fleeting moment. I was lucky to find these ferns spotlit in the New Zealand 'bush', although I could have used flash.

Kidney ferns (*Trichomanes reniforme*)
North Island, New Zealand, February
Nikkormat FTN, 55mm macro lens,
Kodachrome II (ISO 25)

POINT TO WATCH

● *Look also for distinctive silhouettes against a bright backdrop. In this situation, shape alone separates subject from background.*

Maximizing Depth of Field

DEPTH OF FIELD can be increased either by decreasing the magnification or by stopping down the lens. If the subject is moving, however, the aperture which you select may be determined by the slowest shutter speed which you can use without risk of subject blur. It was late in the day when I spotted a large orchid spike from the car, so I used fill-flash (see pages 42–43) to counteract the cast of the evening sun. For maximum depth of field, I focused manually just behind the front of the orchid, so that when I stopped down to f16 this would bring all the flowers into focus.

Detail of *Barlia robertiana* orchid
Cyprus, April
Nikon F4, 200mm macro lens,
Fuji Velvia (ISO 50) with fill-flash

POINTS TO WATCH

● *By using manual rather than auto-focus on a macro lens, it is possible to focus beyond the front of the subject, thereby increasing the depth of field when the lens is stopped down.*

● *When buying a camera for close-ups, check that it has a depth of field preview button to see which parts of the subject will be in focus.*

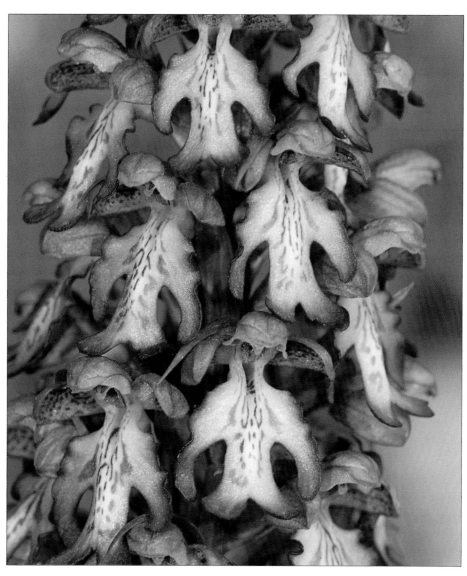

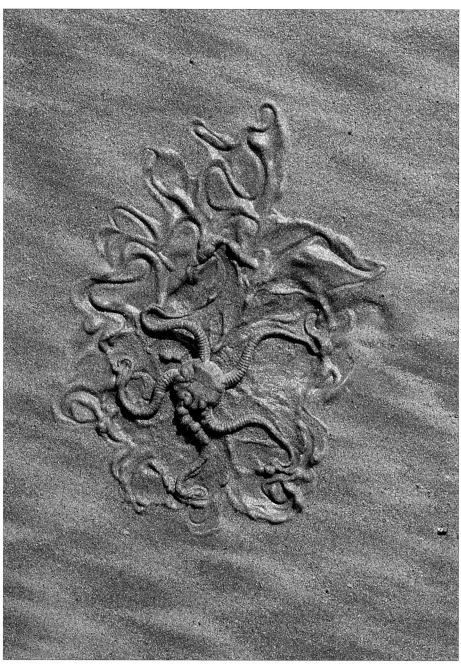

WALKING CLOSE TO THE TIDE LINE on a
sandy beach, I found that a stranded
brittle star had created an intriguing tex-
tured impression by the writhing actions
of its five arms. To maximize on the depth
of field, I supported the camera directly
overhead, checking that the tripod legs did
not cast shadows across the brittle star.
A low-angled sun provided sufficient
modelling to accentuate the texture of the
brittle star and the impression made by the
twisting arms.

Brittle star *(Ophiura texturata)*
Dyfed, Wales, April
Nikkormat FTN, 55mm macro lens,
Kodachrome 64

POINT TO WATCH

● *Always use a tripod to check that the camera
is set up with the film plane parallel to the subject.
The most common cause of close-up pictures
being partly out of focus is the film plane being
at an angle to the subject.*

Shape and Form

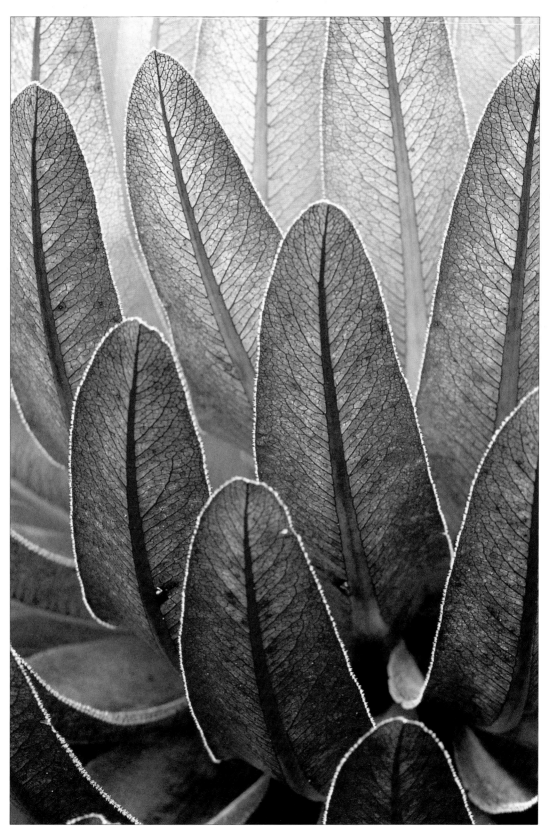

SEVERAL KINDS OF GIANT LOBELIAS grow on mountains in equatorial Africa. Each produces a large basal rosette of leaves before the flower spike develops. I was struck by the colourful undersides of the leaves of one lobelia on Mount Ruwenzori. Having taken a view from above looking down on to the complete rosette, I decided to crop out the background and fill the frame with the overlapping leaves. The red margins clearly define the shape of each leaf, while the juxtaposition of the leaves highlights the growth form of the rosette.

SHAPE CAN BE HIGHLIGHTED by means of a silhouette but, in order to convey both shape and form, careful selection or control of the lighting is required.

After trudging some distance over featureless sand dunes, my eyes feasted upon a pair of leaves casting long shadows late in the day. By echoing the leaf shapes, they create a strong three-dimensional feeling to this simple but effective close-up. The picture would not have worked without the uniform sandy substrate nor with grasses or other leaves in shot. Further emphasis is gained by cropping the picture.

Part of leaf rosette of
Lobelia deckenii bequartii
3,500m up Mount Ruwenzori, Uganda, August
Nikon F3, 105mm macro lens, Kodachrome 25

Shadow cast by sand dune plant
East coast, NSW, Australia, January
Hasselblad 500 C/M, 80mm lens with
1.0 close-up lens, Ektachrome 64

POINTS TO WATCH

● *If a soft natural light does not adequately convey an impression of shape and form, use flash to induce shadows.*
● *With close-ups, even a slight change of camera viewpoint can make a dramatic difference to the way shape and form are interpreted in the picture.*

POINTS TO WATCH

● *Early or late in the day, look for plants growing up through other uni-toned substrates such as mud or snow and utilize their shadows as an integral part of the composition.*
● *Reflections of aquatic plants in water also make effective shape and form studies (see page 102).*

Action Close-Ups

RECORDING ACTIVITY and behaviour in close-up is infinitely more painstaking than achieving a sharp image of a static fungus or lichen. Since the depth of field is limited for all macro subjects, deciding where to focus on a moving subject is crucial. As with larger animals, I always strive for sharply focused eyes.

Having taken this painted lady from above, with the wings sharply in focus, I realized that it was hiding the flower on which it was feeding. By waiting for it to move I was able to get a more unusual view showing the proboscis inserted into the flower. Most of the wings are out of focus, but this is acceptable because they recede behind the sharply focused eyes.

**Painted lady *(Vanessa cardui)* feeding on
*Allium neopolitanum***
Cyprus, April
Nikon F4, 200mm macro lens, Kodachrome 200

POINTS TO WATCH

● *When stalking any insect, avoid sudden, hurried movements.*
● *Be careful to avoid casting your body shadow on to a feeding or resting insect.*

OVER THE YEARS, my garden pond has been a most productive source of wildlife subjects. On a warm day, when many damselflies flit back and forth, I find the best strategy is not to attempt to chase around after them, but to spend time observing their favourite parts of the pond before even setting up the camera.

Dragonflies adopt different methods for laying their eggs; some of the large hawkers repeatedly dip the tip of their abdomen into the water as they hover above, while others alight on emergent plants and walk backwards down the stems until they reach the water surface. The small damselflies opposite were flying around in tandem, with the male grasping the female behind her head, periodically alighting on the waterlily pads, buds or flowers. Provided I made no hurried movements, they remained in position for several minutes before flying off to explore another patch of waterlilies. Their delicacy contrasts with the solid bud that is beginning to open.

Azure damselflies *(Coenagrion puella)*
Garden, Surrey, UK, May
Nikon F4, 200mm macro lens, Kodachrome 200

POINTS TO WATCH

● *Observe the way dragonflies alight, so that you can select the best camera angle. In this case, the slender bodies need to be seen from the side, to show how they link up in tandem.*
● *When using flash to freeze moving insects, mount it, with the camera, on a flash bracket so that only one unit approaches the insect.*

Portraying Texture

L OW-ANGLED LIGHT is crucial for revealing textured surfaces found among fruits, leaves, bark, shells, fossils, reptilian skins and rocks because the shadows it casts reveal the contouring. Rope lava is formed when the surface of a molten lava stream cools and begins to form a crust which is thrown into folds by the hot lava continuing to flow beneath.

On Isla Santiago within the Galapagos Archipelago, I spent an entire morning on an extensive rope lava field finding endless textured close-ups, dramatized by direct sunlight casting obvious shadows.

T HE SURFACE OF LEAVES varies greatly; they can be textured, matt or glossy. Texture can be seen in hairs or spines arising from the leaf surface or in the venation pattern of the leaf itself. The textured leaves opposite were in perfect condition with no distracting blemishes or holes caused by insect damage. I adjusted the camera on the tripod so that the film plane was parallel with the leaves and then stopped down the lens to gain a reasonable depth of field, because I knew that the impact of the texture would be lost if part of the leaf appeared out of focus.

Rope or pahoehoe lava formation
Isla Santiago, Galapagos Archipelago, December
Nikkormat FTN, 55mm macro lens,
Kodachrome II

Rodgersia **sp. leaves**
Chang Mountain, Dali, China, May
Hasselblad 500 C/M, 80mm lens with
1.0 close-up lens, Ektachrome 64

POINTS TO WATCH

● *When taking textured lava or rock, brush or blow away any dust particles lying in the cracks so as to give a cleaner close-up.*

● *A textured surface can be enhanced by holding a flash level with it so that the light grazes across the surface, thereby accentuating the smallest of bumps by the shadows they cast.*

POINTS TO WATCH

● *The texture is more pronounced on many leaves when they first burst open from the bud (see page 79). Poppy petals, for example, are so tightly packed inside the bud that they appear distinctly crinkled when they first open.*

● *Bark and crustose lichens make excellent textured close-up subjects in winter.*

Patterns and Designs

ONE OF THE BEST KNOWN repetitive poly-gonal patterns in nature is honeybee comb; others include tightly packed seeds on a corn-on-the-cob and reptilian scales.

The star tortoise is an endangered animal in Sri Lanka and rarely seen in the wild. When a small boy tried to sell me one, I put it on the ground to get a close-up of the striking polygonal pattern in the carapace. I focused below the highest point of the curved shell, then stopped down the lens to bring it all into focus.

PATTERNS AND DESIGNS abound within the natural world; on both the grand and the small scale. Spirals, polygonal forms and radially symmetrical designs provide end-less scope for taking striking close-ups. Waterlily flowers are radially symmetrical while the petals are spirally arranged. To ensure the white flower was not underex-posed I spot-metered off green leaves at the pond edge, although when I took a matrix reading of the framed picture, I found that the dark lily pads compensated for the white flower.

Polygonal pattern on shell of star tortoise
(Testudo elegans)
Sri Lanka, May
Nikkormat FTN, 55mm macro lens,
Kodachrome 25

White waterlily *(Nymphaea alba)*
New Forest, Hampshire, UK, June
Nikon F4, 105mm macro lens,
Kodachrome 25

POINTS TO WATCH

● *The success of a pattern picture depends on the magnification selected and the way it is cropped, so experiment with these variables.*

● *Compound eyes of flies and dragonflies make exciting extreme close-ups when taken at 3–4 times life size with a bellows extension.*

POINT TO WATCH

● *Overhead views of radially symmetrical sub-jects, including sea anemones and starfish as well as flowers, are best framed within a square format. Here, the original horizontal 35mm frame has been cropped on both sides to make for a better composition.*

Equipment Checklists

When working in a remote location, the price tag on your cameras and lenses is irrelevant if you are unable to take a picture because you lack some vital – often inexpensive – accessory. Over the years, I have compiled my own checklists of useful accessories and gadgets for each habitat type (which I constantly revise) so that I am always well prepared.

The lists below are not definitive; rather they are intended as useful guidelines and may well need to be modified, depending on the type of equipment you use and the subjects you take. I should be interested to hear from anyone who can contribute additional items from their personal experience.

Items on the general list are carried with me wherever I go. Where an item is repeated with an asterisk under a specific habitat, this is to draw attention to it being vital for that particular location.

In addition to special photographic accessories for specific habitats, you will need to wear appropriate clothing for the particular location and time of year. Your photography will suffer if you are wet or cold. Because individuals have different tolerance limits, I have not listed the clothing items but any reputable tour company specializing in wildlife trips to remote parts of the world should be able to supply a recommended clothing list. Some items – notably arctic anoraks and boots – are available only at the appropriate latitudes, e.g. Canada and Alaska.

The following companies specialize in outdoor clothing and have many branches:

IN THE UK
Rohan Designs plc, 30 Maryland Road, Tongwell, Milton Keynes, MK15 8HN.

IN THE USA
Eddie Bauer, 1501 North East 36th Street, Redmond, Washington 98052.
REI, Head Office, PO Box 88125, Seattle, WA 98138–0125.

GENERAL LIST

PHOTO EQUIPMENT
Tripod
Reflector
Diffuser
Polarizing filter
Grey graduated filters
Flash with sync lead
Flash bracket(s)
Spare batteries
Battery tester
Changing bag

CAMERA CARE AND REPAIR
Photographic vest
Padded hip bag for carrying films and
 spare lenses
Domke protective wraps
Poncho to cover rucksack in rain
Cameramac waterproof lens covers
Umbrella for holding over camera in rain
Airbrush
Lens tissues
Watchmaker's screwdrivers for camera
 repairs

MISCELLANEOUS
Black adhesive masking tape (for securing
 lens cases when checked on airlines and
 sealing flash cord connectors)
Cloth tape to tie branches out of field of
 view
Binoculars
Self–adhesive numbered labels
 (to mark films)
Field notebook
Water bottle
Emergency rations
Kodak 18% grey card

OVERSEAS TRIPS
Photocopy of insurance policy listing
 photographic items
Sterile bandages and needles
Anti-malarial tablets for malaria–infested
 areas

SAFARI (DRY SEASON)
*Insect repellant
*Binoculars
*Bean bag, Tribag or window clamp
*Damp cloth (a dust wipe)
*Blower brush
Monopod
Shoulderpod
Tele-extender/converter
Dust mask
Large dust-proof bags
Insulated picnic box for films

TROPICAL RAINFORESTS
*Insect repellant
*Airtight picnic boxes with indicator silica
 gel crystals (loose crystals can scratch
 lenses) in perforated plastic bags for films
*Flash
*Cameramac covers
*Sweat bands
*Waterproof notebook and pencil
Waist pouch for spare gear
Waterproof tape to protect flash
 connections
Reflector
Plastic groundsheet/dustbin bag
 (to protect equipment on wet ground)
White or clear plastic umbrella (to protect
 camera on tripod from rain)
Waterproof bag or case, such as Pelican
 case
Hand towel

ARCTIC CONDITIONS
*Remote cold-weather battery pack
*High-energy lithium batteries (LithEon in
 UK, Energizer in USA)
*Tri-pads to insulate tripod legs (or foam
 strips for pipe insulation)
*Polariod sunglasses to reduce glare from
 snow and ice
Home-made thermal camera jacket
Thermometer on key-ring to fix to gadget
 bag
Chemical handwarmers

Plastic groundsheet/dustbin bag (to
 protect equipment on snow-covered
 ground)
Plastic sledge for carrying equipment over
 snow
Sweat bands for insulating focusing ring
 on long lenses

WETLANDS
*Polarizing filter
Waterproof camera
Benbo tripod with submersible legs
Waterproof bag or case such as Pelican
 case
Padded waist/hip pouch(es)
Gum boots or waders
Waterproof quick-fastening bags
(white–water stuff sacks)
Polaroid sunglasses

AT SEA
*Polarizing filter
*Binoculars
*Zoom lenses
*stop-watch for timing whale's dive
Skylight filter
Shoulderpod or monopod for working in
 small boats
Polaroid sunglasses
Waterproof bag or case, such as Pelican
 case
Underwater camera

MOUNTAINS
*Binoculars
*Skylight filter
*Polarizing filter
Low-level tripod – such as Baby Benbo –
 for prostrate alpines
Compass
Plant clamp
Emergency rations
Polaroid sunglasses

Glossary

Aperture–priority Automatic metering mode which allows manual selection of the aperture while the camera sets the appropriate shutter speed. Useful when a precise aperture is required in order to isolate a subject from the background or to gain maximum depth of field.

Available light Natural light which, depending on the amount of cloud cover, can vary from bright sun (with obvious shadows) to soft sun (with weak shadows) to completely overcast (with no shadows).

Bracketing A series of frames taken by varying each exposure by half or one-third of a stop increments on either side of the metered exposure to ensure that one will be correct. Auto-bracketing is *not* advisable for action shots, since out of every three shots, two are likely to be incorrectly exposed.

Depth of field Zone of sharp focus in front of and behind the plane of focus. Increased by using a smaller aperture or by decreasing the magnification. Important with long telephoto lenses and in close-up work when depth of field is limited.

Diffuser A substance (muslin, artist's trace, tissue or greaseproof paper), or a purpose-built photographic diffuser used to scatter light to give a soft even lighting.

Exposure compensation Adjustment to ensure correct exposure when taking very light (white-coated animals or snow-covered ground) or very dark (black rock) subjects. This can be done by adjusting either the aperture or the shutter speed, by adjusting the exposure compensation dial or by changing the film-speed dial (but remember to reset the dials when taking average-toned subjects).

Fill-flash Flash balanced with available light to fill shadow areas or add highlights to raindrops or dark eyes.

Film speed Relative sensitivity of a film to light, expressed as an ISO (International Standards Organization) rating. 'Slow' films such as Kodachrome 25 have a low rating and require more light than 'fast' films such as Ektachrome 400, but they produce a more crisply defined image without any obvious grain. Film is normally exposed at the given speed, but it can be rated at a different speed (most often it is 'pushed' to a higher speed to gain an extra stop in poor light) for the entire roll.

Filters Transparent or translucent substance (glass, plastic or gelatin) which alters the colour or amount of light passing through it, placed either in front of the lens or, in the case of long telephoto lenses, in a slot behind the rear lens element.
 Graduated Used to reduce the contrast between one part of the frame and another (e.g. an uncoloured sky and land) by adding colour to the sky. Available in different colours and densities.
 Neutral density Pale grey filters (available in different strengths) which reduce the amount of light reaching the film and therefore effectively reduce the film speed. Useful when long exposures are required to blur moving water.
 Polarizing filter Used to reduce distracting skylight reflections from water or wet and shiny surfaces. It also increases the colour saturation in green grass and leaves and darkens blue sky.
 Skylight (Haze) Absorbs ultra-violet 'haze' and reduces the bluish cast in landscapes and is particularly useful when working at altitude or beside the sea. It can also be used to protect the lens from rain, salt spray or scratching.

Flare Bright spots or patches formed by strong light reflections inside the lens, when the camera is pointed towards a light source. Flare can be eliminated or reduced by using a lens hood and by stopping the lens down to a small aperture.

Grazed lighting (Textured lighting). Extreme low-angled oblique lighting used for emphasizing texture.

Incident light Light falling on a subject. See *Reflected light*.

Metering Most single lens reflex cameras with through-the-lens (TTL) metering use a centre-weighted system, whereby the centre of the frame is metered most accurately. This is fine if the main point of interest is centrally placed.

Matrix Meters all over the frame and takes an average of the areas. Works well for pictures that have no extreme bright spots or shadows.

Spot Enables a very small area of the frame to be precisely metred. Provides the opportunity for accurate manual metering of different parts of the frame.

Monopod A single-legged camera support.

Panning Horizontal movement of camera (hand-held or on a tripod) to keep a moving subject in the viewfinder and to blur the background.

'Pushing' Re-rating film at a higher speed than nominal rating. See *Film Speed*.

Reflected light Light reflected from the subject. See *Incident light*.

Reflector A surface used to deflect light onto the subject, particularly useful for filling-in shadows.

Shutter priority Automatic metering mode which allows manual selection of the shutter speed while the camera sets the appropriate aperture. A fast speed is selected to freeze action, a slow one for a static subject or to create fluid lines conveying movement.

Stop down Closing down the lens aperture to a smaller aperture to increase the *depth of field*.

Tri-pads Foam tubes (slit lengthwise) covered with black waterproof nylon cover secured by Velcro, used to insulate metallic tripod legs in freezing temperatures.

Acknowledgments

Many people have helped me to obtain pictures for this book. I am especially indebted to the companies, organizations and individuals who either assisted me with my photography or in my travels to remote parts of the world. Many thanks to you all for your help and kindness: Abbotsbury Swannery; Abercrombie & Kent Travel; Ken Allaman; Dr Akira Aoki; Biological Journeys; British Petroleum; Georgina Corrigan; Bruno and Rika David; Jay Deist; Mike Durban, Blue Fjord Charters; Ever-Ready Ltd; Michelle Gilders; Alan Goodger; Dan Guravich; International Fund for Animal Welfare (IFAW); Joe Van Os Photo Safaris; Mr Fujio Kanchi; Kodak Ltd; Mrs Satsue Mito; Francis Mbuthia Muchiri; The National Trust; Nikon UK Ltd; Occidor Adventure Tours Ltd; 'Moose' Petersen; Michael & Jan Ramscar; Dave Richards; Royal Botanic Gardens, Kew; Mr Tetuo Sato; Doug Seus; Ed Slater; Station Biologique de la Tour de Valat; Adrian and Jimmy Storrs; Mr Eishi Tokita; Tundra Buggy Tours; Mr Kunio Watanabe; Wildfowl and Wetlands Trust; Don Winkelman; Pat Wolseley; Mr Naotsugu Yamaguchi; Zambian Photographic Society.

I should also like to thank Colour Processing Laboratories for processing all my E6 films (Ektachrome and Velvia) and Dennis Orchard Duplicates for duping all my action shots which are reproduced in this book. Special thanks go to Sue Corkhill for producing the manuscript from my notes or dictation and to Rona Tiller for assisting with checking the manuscript. I am also indebted to John Meek of Toucan Books Ltd for creating such attractive – and varied – designs to the spreads and to Sarah Hoggett at Collins & Brown for her meticulous editing. Not least, fond thanks to my husband, Martin Angel, for tolerating my frequent trips away from home and for his constant encouragement.

Index